SECRET TWICKENHAM, WHITTON, TEDDINGTON AND THE HAMPTONS

Andy Bull

AMBERLEY

First published 2020

Amberley Publishing
The Hill, Stroud
Gloucestershire, GL5 4EP

www.amberley-books.com

Copyright © Andy Bull, 2020

The right of Andy Bull to be identified as the Author
of this work has been asserted in accordance with
the Copyrights, Designs and Patents Act 1988.

ISBN 978 1 4456 9692 8 (print)
ISBN 978 1 4456 9693 5 (ebook)

British Library Cataloguing in Publication Data.
A catalogue record for this book is available from the
British Library.

Origination by Amberley Publishing.
Printed in Great Britain.

Contents

Preface

Everyone has heard of the Cavern Club, but few know of its southern equivalent on Twickenham's Eel Pie Island. Yet this club, which prospered here in the early sixties, was every bit as important as its Liverpool counterpart, nurturing The Rolling Stones, Rod Stewart, Eric Clapton, David Bowie and many others. Its story, and that of the remarkable man who ran it as a social experiment in helping troubled youths, is just one of the lesser-known topics we shall explore here.

Many of these tales concern the River Thames, which is the thread that pulls everything together as it runs through the story of Twickenham, Whitton, Teddington, and the Hamptons. The Thames brought work to the watermen, ferrymen and fishermen, provided food from its once-abundant stocks of salmon, eels and trout, and offered the perfect transport artery to the city of London.

The rich loam along the river attracted market gardeners, who took their harvests to Covent Garden, and won this area the title of the Garden of England. In the eighteenth century, the Thames brought the rich, famous and distinguished, who built grand riverside houses and made this the cultural hub of England. And, of course, the jewel in the area's crown is Henry VIII's palace at Hampton Court. However, Henry was by no means the main architect of the palace, and there are other, equally key, individuals whose contributions we shall explore.

There are also unexpected stories to uncover about the film studios at Twickenham and Teddington, and how Twickenham became the home of English rugby.

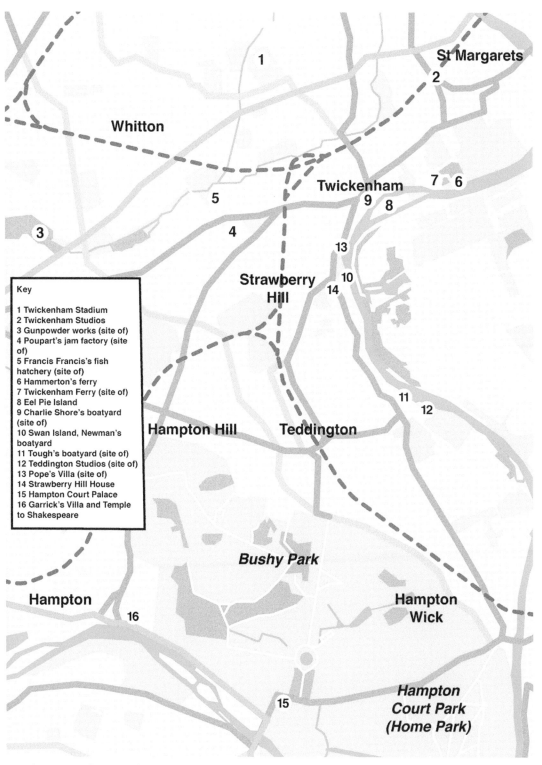

St Margarets

Whitton

1

2

Twickenham

7 6

5

9 8

3

4

13

Strawberry
Hill

10

14

Key

1 Twickenham Stadium
2 Twickenham Studios
3 Gunpowder works (site of)
4 Poupart's jam factory (site of)
5 Francis Francis's fish hatchery (site of)
6 Hammerton's ferry
7 Twickenham Ferry (site of)
8 Eel Pie Island
9 Charlie Shore's boatyard (site of)
10 Swan Island, Newman's boatyard
11 Tough's boatyard (site of)
12 Teddington Studios (site of)
13 Pope's Villa (site of)
14 Strawberry Hill House
15 Hampton Court Palace
16 Garrick's Villa and Temple to Shakespeare

Hampton Hill

Teddington

11

12

Bushy Park

Hampton

Hampton
Wick

16

Hampton
Court Park
(Home Park)

15

(Map: Emily Duong)

1. Tales of the River

For centuries, Twickenham, Whitton, Teddington and the Hampton were bucolic places; a string of villages alongside the great water-highway of the Thames. With poor and often impassable roads, the river was the main transport route. It offered a livelihood to many through fishing, ferrying, boat hire and boatbuilding. The river, however, could be a dangerous foe, and it took many centuries to tame it.

Ferry Wars

Today, Hammerton's is the only ferry on this stretch of the Thames, and the sole crossing point between Richmond Bridge and Teddington Lock footbridge. It takes foot passengers from Ham House, on the Richmond side of the river, to east Twickenham. Yet, in 1909 Hammerton's was an upstart, threatening the trade of the ancient Twickenham Ferry, known to have been operating from at least 1652, which ran from upriver of Ham House, passing the tip of Eel Pie Island to reach a slipway on Twickenham Riverside, adjacent to the White Swan pub.

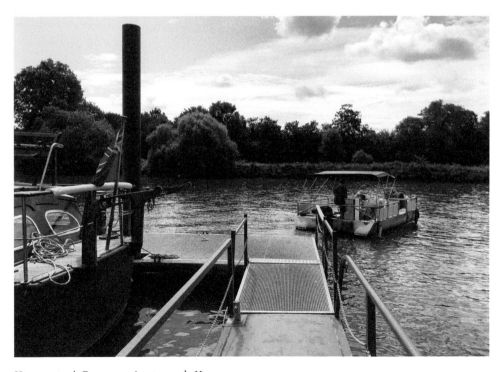

Hammerton's Ferry crossing towards Ham.

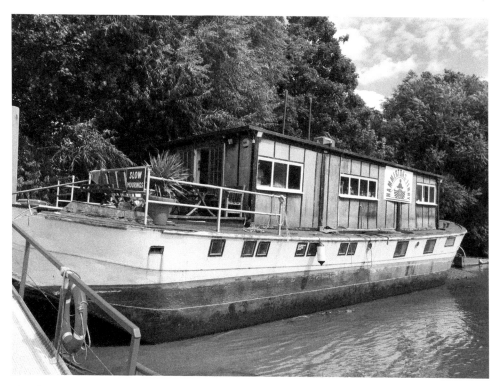

The floating ferry terminal.

This was some distance from the main focus for Twickenham's river traffic, which was where the Waterman's Arms stood at the foot of Water Lane. It did, however, suit the men who hauled barges upriver, as the towpath crossed from the Surrey to the Middlesex banks at this point. The ferry enabled them to get across and continue their arduous journey upriver.

The Dysart family, owners of Ham House, claimed the right to licence ferrymen on this stretch of the river. The background to the dispute with Hammerton was the development of the banks of the Thames as a place of recreation. In 1901, the extensive riverside grounds of Marble Hill House, on the Twickenham bank, were opened to the public. In 1902, a public right of way was established along the Richmond bank past Ham House.

In 1908 Walter Hammerton, whose family of watermen, ferrymen and boatbuilders dated back to at least 1610, obtained a licence from the Port of London Authority to moor a floating boathouse on the Twickenham bank, adjoining Marble Hill Park. He rented out rowing boats from here, but got so many requests to row people across between Marble Hill and Ham House that, in 1909, he set up a ferry service, charging 1d a crossing and making £12 a year.

Lord Dysart and William Champion, who operated the Twickenham Ferry, saw this as a threat to the £150 they made per year and objected. When their letters were ignored, they took legal action to try to have this upstart rival closed down, claiming the sole right to run ferry services between Ham and Twickenham. Dysart claimed this right had been

Ferry Road meets Riverside beside The White Swan.

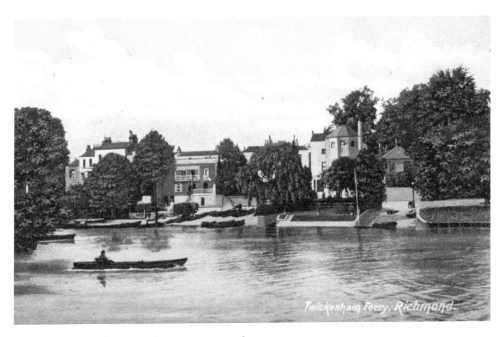

The ferry in an early twentieth-century postcard.

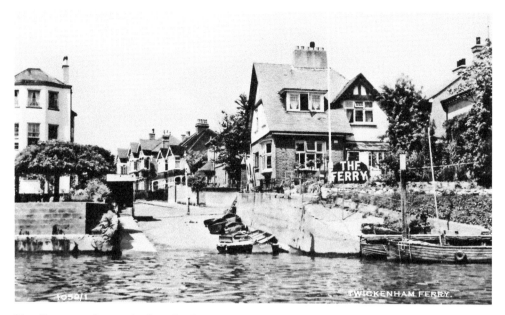

The slipway on the Twickenham bank before its closure.

exercised by his ancestors for 'upwards of 300 years', although the ferry probably dated from between 1637 and 1642. It took years of court action but, in 1915, the House of Lords ruled in Hammerton's favour.

Back in 1878, Twickenham Ferry had been immortalised in song, when Theo Marzials had a huge hit with 'Twickenham Ferry, A River Ditty'. Now, a song was written to celebrate the victory of the upstart, entitled 'Hammerton's Ferry: The Ferry to Fairyland', Fairyland being a reference to the wonders of Marble Hill. It too was a hit.

The magazine *Musical Jottings* said 'Twickenham Ferry, A River Ditty' was 'The song of the season, a perfect gem!' It was still popular in 1950, when John Betjeman included it in a Christmas Eve radio programme, but its words read curiously to modern sensibilities. The song warns women of the risk of trusting the ferryman, and, if taken literally, suggests the need for a safer way to cross the river.

The lyrics run, in part:

> The ferryman's slim and the ferryman's young,
> And he's just a soft twang in the turn of his tongue,
> And he's fresh as a pippin and brown as a berry,
> And 'tis but a penny to Twickenham town.

A young lady wants to cross, but there is a problem:

> it's late as it is, and I haven't a penny,
> And how shall I get me to Twickenham town?

The ferry man takes her, but:

> he's not rowing quick, and he's not rowing steady ...
> The moon is a rising on Petersham Hill,
> And with love like a rose in the stern of the wherry.
> There's danger in crossing to Twickenham town.

The second song, 'Hammerton's Ferry: The Ferry to Fairyland', with lyrics by Arthur M. Young and music by W. F. Clarke, paints a very different scene, with the threat from the lusty ferryman replaced with the charms of mythical creatures. Here, it is the passengers who become 'brown as a berry' rather than the ferryman.

The song speaks of 'a spot where sorry is not,/And workaday cares are banned' and waxes lyrical about 'the elves in the dells', 'the fairies and gnomes that have their homes' and 'the sedges that swish where the moon-eyed fish/Roll lazily over the sand'.

The song was presented in a triumphalist way. The front cover of the sheet music read:

> In commemoration of the Victory in the House of Lords on July 23rd 1915,
> AFTER SIX YEARS LITIGATION
> When by the unanimous direction of Lords Haldane, Porter, Strathclyde, Sumner
> and Parmoor,
> WALTER HAMMERTON
> Won the right to ferry across the river from Richmond Riverside Promenade to Marble
> Hill Park, Twickenham-on-Thames
> FOR THE PUBLIC.

Following the Lords' judgement, both ferries operated and thirty years later the dispute was clearly forgotten. In July 1947 a cruise was held upriver from Richmond, with both ferry songs sung at appropriate points on the journey. Walter Hammerton retired in 1947, but the ferry continued to run with new owners. Hammerton's original twelve-passenger wooden rowing boat, a traditional Thames skiff, is now in the Museum of Docklands.

Twickenham Ferry continued to operate through the 1960s but, with passenger numbers falling, its days were numbered. It closed in 1970, but not before enjoying something of a swansong, appearing in the TV series *Elizabeth R*, starring Glenda Jackson, in a scene in which the future queen is rowed downriver to her incarceration in the Tower of London.

The Bawdy Boat

The Dysart family had had greater success in a previous effort to ban a rival ferry in 1746. This took passengers to a barge, *The Folly*, which was moored off Twickenham and was a centre for 'indecent' activities.

On 28 May 1745, the Court of Aldermen was told that several Twickenham residents had complained that 'there is lately fixed near the Shore of Twickenham on the River Thames a Vessell made like a Barge and called the *Folly* wherein divers loose and disorderly persons are frequently entertained who have behaved in a very indecent Manner and

DID YOU KNOW?
Professor Cockles, the Tin Can Diver, was a famous figure who entertained crowds on Twickenham Embankment from the 1930s to 1970s with his underwater stunts. Dressed in bizarre home-made diving equipment made from scrap, he would perform regular Sunday feats in which he dived from bridges while on fire, and strapped fireworks to his helmet for underwater firework displays.

do frequently afront divers persons of Fashion and Distinction who often in an Evening Walk near that place, and desired so great a Nuisance might be removed.'

The Lord Mayor of London was authorised to take action, but it was Earl Dysart who proved decisive, taking the matter to the Court of Common Pleas and obtaining a judgment against both ferry and bawdy boat, which forced their closure.

Boatyards and Boatbuilding

Thames watermen were of vital importance to life along the Thames. As well as operating ferries and hiring out boats, they transported goods on the river. There was also extensive boatbuilding at Twickenham, Teddington and Hampton.

Charlie Shore's Boatyard, Twickenham

Charlie Shore's boatbuilding and boat hiring yard stood on Twickenham Embankment, close to where the bridge to Eel Pie Island is today. Charlie was born in 1858 in Bell Lane,

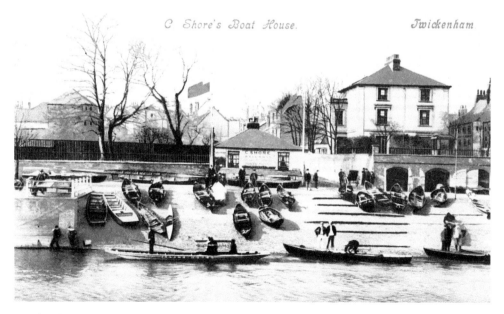

Charlie Shore's boatyard at Twickenham in 1905.

Twickenham Embankment today.

which runs from the Embankment to Church Street. He was apprenticed to his uncle, Edward Hammerton of the long-established family of watermen, in 1873. He is still remembered today through Charlie Shore's Twickenham Girls' and Boys' Regatta, which he established in 1894. It became an annual event and ran until the 1950s. It was revived in 2011.

In 1926, redevelopment at King Street and the widening of Water Lane led to his son, Charlie Jnr, selling up to another member of the Hammerton family, but the boatyard survived until 1944, when it is believed to have been damaged by a V1 flying bomb, which destroyed houses in Gotham Villas, at the southern end of Water Lane, killing several inhabitants including Fred Hammerton.

Eel Pie Slipways, Twickenham

One boatyard that survives in Twickenham is Eel Pie Slipways, owned for over forty years by Ken Dwan, whose family have worked on the Thames for over 500 years and who was an Olympic rower. Eel Pie Slipways was owned in 1907 by Joseph Mears (1871–1935), who built up the largest fleet of passenger launches on the Thames. Mears's pleasure boats took tourists upriver to Henley and beyond, and downriver to the City. The company sold up in 1947.

Joseph and his brother Gus were co-founders of Chelsea Football Club in 1905. They had purchased the Stamford Bridge Athletics Ground in 1896. Joseph's son, Joe, and grandson Brian both went on to chair the football club.

Eel Pie slipways.

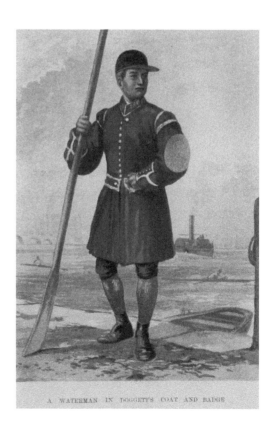

A WATERMAN IN DOGGETT'S COAT AND BADGE

Doggett's Coat and Badge uniform.

Ken Dwan was born in Bermondsey and worked the river around Rotherhithe. From an early age, Ken was a brilliant rower, competing in the single sculls at the Olympic Games in Mexico City in 1968 and Munich in 1972, while working as a lighterman, crewing lighter, flat-bottomed Thames barges.

One of his proudest achievements was winning a race called Doggett's Coat and Badge, established in 1715 and the oldest rowing race in the world. Apprentice Thames watermen compete, in replicas of boats once used to ferry passengers across the Thames, for a cash prize, plus a traditional waterman's red coat and silver badge.

The race was named after Thomas Doggett, manager of the Theatre Royal, Drury Lane who, attempting to get across the river late at night, found no watermen willing – or sober – enough to take him. Eventually a young apprentice did and, in appreciation, Doggett left funds in his will for a race between six watermen who were just finishing their apprenticeships.

Newman's Shipyards, Swan Island

Swan Island, at Strawberry Vale, Twickenham, was originally an undistinguished mudflat known as Milham's Ait, after its owner Harry Milham, a builder of both houses and boats. When Milham worked on the construction of the London Underground in the 1890s, he brought clay dug out during the excavation of tunnels here and built up the island.

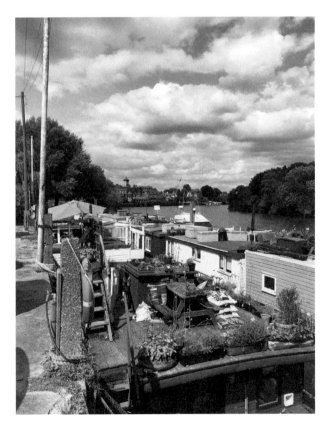

Houseboats now cluster around Swan Island.

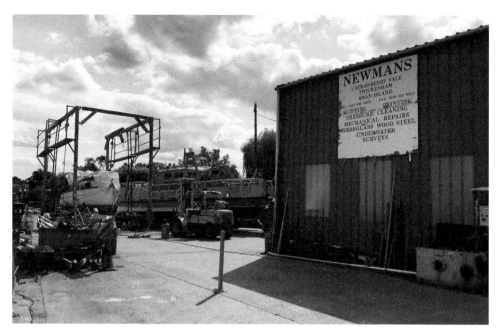

Newman's boatyard on Swan Island.

Milham also had a boatbuilding business on the riverbank adjacent to the island. Frank Newman bought the yard, and the island, in 1962. In the 1990s he and his daughter, Fiona Gunnion, further increased the height of the island and transferred the boatyard over from the mainland. The yard repairs many of the forty houseboats that are moored around it, as well as Thames Fire Patrol boats. Frank developed other boat businesses from as far afield as the Clyde and Ramsgate, Kent, and in 1969 became joint owner of Tough's Boatyard at Teddington. Fiona now runs the business at Swan Island.

Tough Brothers, Teddington

The first tenant of the boatyard at the end of Ferry Road – at the limit of the tidal Thames alongside Teddington Lock, which it predates by some forty years – was James Messenger. He was also Royal Bargemaster, playing an important role in state ceremonies involving the Thames, from 1862 to 1890. He also had a yard in Kingston. In around 1875 he was commissioned by Sir Henry Morton Stanley to build a rowing boat, the *Lady Alice*, which could be dismantled into five sections for transport overland and was used on Stanley's African expeditions.

The Tough family took over the yard in the 1930s. They also had a yard at the end of Manor Road, Teddington, and ran a ferry between Richmond and Kingston. Under Bob Tough (1926–2012) and the sixth generation of watermen in the family, the firm built the *Royal Nore*, used for over forty years from 1971 whenever a member of the royal family travelled on the Thames on an official engagement.

In 1954 Toughs built *Havengore*, which carried Sir Winston Churchill's coffin up the Thames after his state funeral at St Paul's. A global TV audience estimated at 350 million watched the boat as it bore the coffin from alongside the Tower of London upriver to

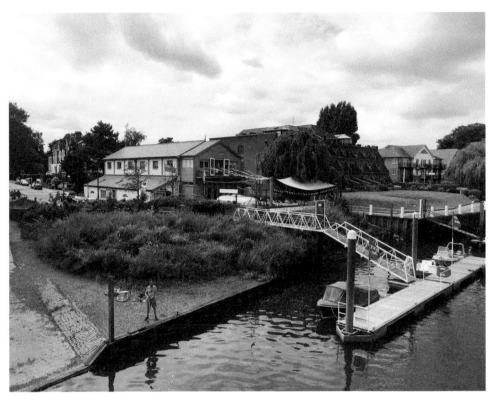

The building alongside Teddington Lock that housed Tough's boatyard.

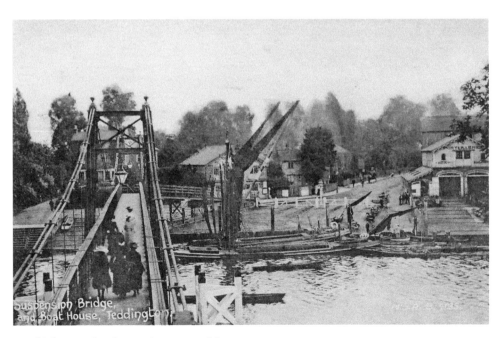

Tough's boatyard under previous ownership.

Waterloo, where it transferred to a special train for burial at St Martin's Church, Blaydon, near Woodstock, in Oxfordshire. Both vessels took part in the 2012 Thames Pageant marking the Queen's Diamond Jubilee.

Under Bob's father, Douglas, the operation to rescue troops stranded at Dunkirk in 1940 was masterminded. We shall look at that in detail in chapter 8. Tough's has built everything from police motor launches to a 20-foot scale model of the whaler *Pequod* for the 1956 film *Moby Dick*, starring Gregory Peck, and a dinghy for the Bond movie *From Russia with Love*.

The yard closed in the early 2000s and the buildings, which date from 1862 and are Grade II listed, are now offices and a chandlers' shop.

Taming the River: Bridges, Locks and Weirs

Until Richmond's was built in 1777 there were no bridges across the Thames between London and Kingston, where a wooden bridge had connected that town with Hampton Wick from 1219. The old bridge, demolished in the nineteenth century when the present stone structure was built, survived largely unaltered for 600 years, despite being in a state of constant disrepair. It stood 50 yards downstream of the present bridge, linking Old Bridge Street at Hampton Wick with Kingston, at a point now beneath John Lewis and the riverside walk.

One problem for those who relied on the river for their livelihood was that, at low tide, it emptied, severely reducing its navigability. Artificial means to restrict the flow of water on the ebb tide began at Teddington, where a weir was constructed in 1345. In 1811, a lock was built, which meant the Thames was always navigable upriver of that point.

That didn't help Twickenham though, where there was little more than mud at low tide. The situation worsened from 1831 with the removal of the old London Bridge, whose many supporting pillars acted as a weir, and again in 1852 as a result of water companies extracting increased amounts to serve London's fast-expanding population. As a result, barge traffic could no longer serve Twickenham at low tide. The problem was resolved in 1894 when the Richmond Half-tide Lock and Weir was constructed downriver of Richmond Bridge, making the river only semi-tidal and ensuring sufficient water was retained at all times.

DID YOU KNOW?
Eccentric Hampton resident May French Sheldon (1846–1937) set out on a journey of discovery to Africa in 1891, for which she packed a sparkling ballgown and full set of jewellery so that she could be appropriately dressed when received by tribal chiefs. As she journeyed through the continent she would send a messenger ahead to announce that she was 'a great white queen of limitless powers, come to make friends'. On her return she was visited at her home in Thames Street by Henry Morton Stanley, discoverer of Dr Livingston. She became the first woman member of the Royal Geographical Society.

Floods

The other challenge the river posed was the opposite problem: when too much water caused flooding. The worst floods of the eighteenth century reached their zenith on 12 March 1774 when, after heavy rains over the Thames basin, the river rose by 10 feet and Hampton, Teddington and Twickenham were inundated. Plaques recording the record levels the waters reached can be seen at the Old Ferry House, Hampton, high on the churchyard wall at St Mary's, Twickenham, and at Radnor Gardens alongside the river at Cross Deep.

Less serious flooding returned in September 1774 and Horace Walpole, who lived at Strawberry Hill House, wrote to his cousin Henry Seymour Conway:

It has rained this whole month, and we have got another inundation. The Thames is as broad as your Danube, and all my meadows are under water. Lady Browne and I, coming last Sunday night from Lady Blandford's, were in a piteous plight. The ferry-boat was turned around by the current, and carried to Isleworth. Then we ran against the piers of our new bridge.

The ferry Walpole refers to was one that travelled upriver from Richmond to Twickenham, and was discontinued when the new bridge at Richmond which he mentions was completed three years later.

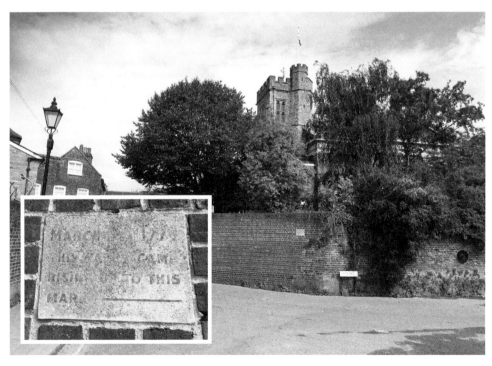

St Mary's Church, Twickenham, with (inset) the stone marking the point floodwaters reached in 1774.

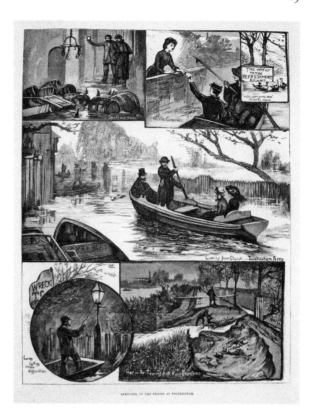

A newspaper illustration of the floods of 1882.

The worst floods of the twentieth century came on 7 January 1928 when a combination of heavy snows over Christmas at the source of the Thames, followed by a sudden thaw and heavy rain over New Year, came up against a storm surge in the North Sea, which funnelled water upriver. This was the last major flood to affect central London. Water levels reached their highest point on record and the House of Commons and Tate Gallery (now Tate Britain) were flooded. Meanwhile, upriver, the Thames and River Crane, which flows into the Thames at Twickenham, flooded in St Margaret's.

It was as a result of this flood that discussions began that eventually led to the creation of the Thames Barrier at Woolwich, which, since its completion in 1982, has prevented flooding as a result of sea surges.

Pleasure on the River: Three Men in a Boat

From the 1860s, the Thames became hugely popular as a place of relaxation. Many would take a train out of the smoke and hire a rowing boat from Twickenham, Teddington or Hampton and enjoy a leisurely day on the water. So many small boats were being taken out that, in 1869, a boatslide was installed at Teddington, with rollers to allow small craft to pass without going through the lock.

Jerome K. Jerome's classic 1889 comic novel *Three Men in a Boat* tapped into the highly fashionable sense of the river as a place of escape, fun, adventure and relaxation. The book, about three friends who row upriver from Kingston, chimed with the many

Houseboats at Tagg Island. (Motmit under Creative Commons)

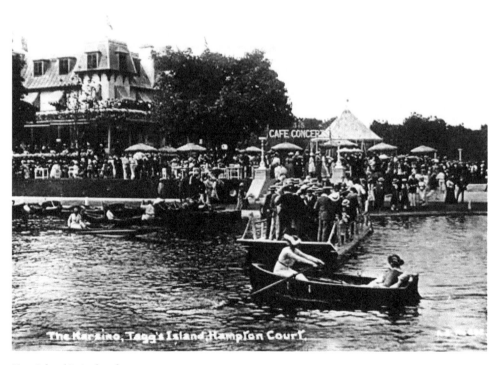

Tagg Island in its heyday.

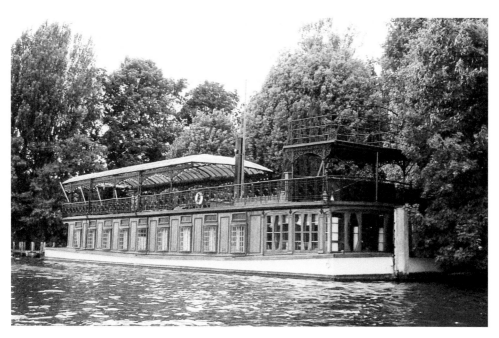

Astoria – David Gilmore's recording studio. (Motmit under Creative Commons)

inexperienced boaters who, like Jerome's characters, get into mishaps on the river. The boat they used was a Thames camping skiff, a wooden rowing boat adapted from the traditional Thames wherries that had been used for centuries on the river for fishing and transport.

Thames boatmen discovered they could make more money out of tourism than they could from their traditional crafts and diversified. On Tagg Island, Tom Tagg built the Thames Hotel in 1872, where the future Edward VII was among the well-heeled Londoners who came.

The hotel was later taken over in 1912 by the music hall impresario Fred Karno, rebuilt and expanded into a full-scale resort that included a music hall called the Karsino and which he claimed was 'the hub of the universe for river people'. During the First World War the resort was popular with servicemen returning from the Front, and Karno organised entertainment and picnics for wounded soldiers. Post-war, the resort's popularity faded. Karno was declared bankrupt in 1925 and sold up. A vehicle ferry to the island was introduced in an attempt to attract more visitors, but the complex closed again in 1940. The hotel was demolished in 1971 and fire destroyed the other buildings.

The island is now owned by those who live in houseboats along its banks, but one memory of Tagg Island's glory days survives: the grand houseboat, the *Astoria*, which Karno moored on the island. It was bought in the 1980s by David Gilmore of Pink Floyd and converted into a recording studio. It is moored just upstream of the island on the northern bank. Pink Floyd's last three studio albums – *A Momentary Lapse of Reason*, *The Division Bell* and *The Endless River* – were partly recorded here, as were Gilmore's solo albums *On An Island* and *Rattle That Lock*.

2. Tales of the Riverbank: Market Gardening and Fish Farming

The ease of access that the River Thames gave to London, and the fine, fertile loam along its course, meant that market gardens thrived throughout Twickenham, Whitton, Teddington and Hampton from the seventeenth century to the early twentieth.

Ronald Webber, in his book *Covent Garden: Mud Salad Market*, writes that, in the seventeenth century, 'London probably had the first true market gardeners – that is men who grew produce entirely for sale to the public.' From Twickenham, Teddington and elsewhere upriver they would travel to Covent Garden and 'set up their stalls in the Piazza outside the garden wall of Bedford House, forming the embryo of the subsequently famous fruit, vegetable and flower market'.

Maps from the 1800s show that virtually all the land along the river from Richmond to Hampton was under cultivation, and market gardens were huge employers, with 15,000 working on them in the wider area in the 1840s, and around 40 per cent of the land around Twickenham under cultivation.

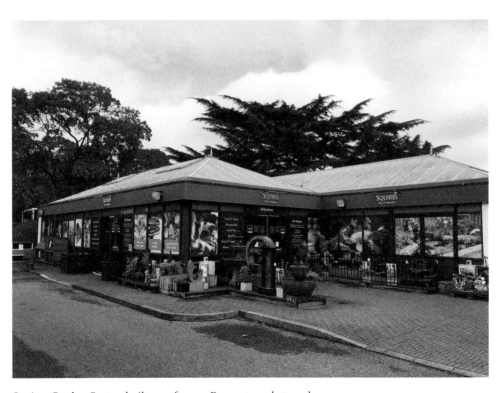

Squires Garden Centre, built on a former Poupart market garden.

Pouparts Place, on the site of the Poupart jam factory.

The population of London rose enormously during the nineteenth century, from 1.1million to 6.6 million between 1801 and 1901, with a corresponding surge in the demand for fresh produce. A report from 1906 calculated that for each 50 to 100 acres, between 60 and 120 hands could be employed. At harvest time, workers would walk from Wales, and others were drawn in from France, Belgium and Germany.

By 1900, Hampton boasted thirty-two market gardens. Whitton was known for its apple, plum and pear orchards, and for its roses, narcissi and lily of the valley. Twickenham was particularly famous for strawberries. The area became known as the Garden of England, a title these days claimed by the county of Kent.

Most of the produce went by boat straight to Covent Garden. The boats came back loaded with manure from the city's horses, and 'night soil' from human sources, which was used to fertilise the fields.

The arrival of the railway in 1848 was both a boon and a curse for the market gardeners. It meant that food could be transported swiftly and cheaply to the city, but also brought a huge increase in demand for land for housing. Suburbia spread along the Thames, pushing the market gardens out of Twickenham towards Whitton. The number peaked in Twickenham in 1870, but in Whitton the area under cultivation continued to increase well into the last century. By the 1970s all had gone.

The Poupart Family

Ronald Webber writes that 'The fillip to market gardening had come from the influx of Protestant refugees from the Continent, quite a number of whom brought with them the skill in intensive market gardening for which the Dutch, Walloons and French had been famous for many years.'

Among those families were the Pouparts. They believe their French Huguenot ancestor Jean Poupart was a market gardener who arrived in England in the eighteenth century. In 1776 his son, Jacques, established a garden in Chelsea, on land which is now home to Stamford Bridge, Chelsea Football Club's ground. Subsequent generations of what was a very extensive family had market gardens in Battersea and elsewhere. London's demand for housing pushed the market gardeners further upriver, and William Poupart moved from Bermondsey via Kew to Twickenham in 1874.

David Rose, in *The Poupart Family in the Borough of Twickenham*, says that when he first moved to Twickenham, William farmed several parcels of land to the east and west of London Road between Cole's Bridge and Ivy Bridge. He rapidly expanded the areas he was cultivating, combining market gardening with arable farming.

In 1879, he added Marsh Farm to his holdings and moved his family there, cultivating 160 acres of land north of the railway line between St Margaret's and Whitton, including the area where Twickenham Stadium now stands. William Poupart planted apple, pear, plum and cherry orchards, the trees underplanted with lettuce and cauliflowers. He developed a variety of plum called Poupart's Purple, and a range of daffodils named after members of the family, including one – a large-cupped white variety – after his wife, Sarah.

The Poupart jam factory in Third Cross Road.

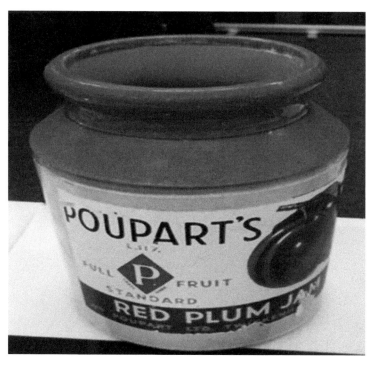

A Poupart jam pot.

Poupart jams were exported to America.

The Poupart's family history website reveals that William's son John had the job, from age sixteen, of selling the family's produce at Covent Garden Market. He was so effective that, in 1895, a group of small growers in Hampton asked him to sell their products for them. John opened an office in Henrietta Street, just off Covent Garden, and a warehouse in Drury Lane. He formed a separate business, under the name TJ Poupart – the T standing for Twickenham – to differentiate himself from another Poupart with the same Christian name in Essex, and began to also farm in the Lea Valley.

At Covent Garden another opportunity for expanding the family firm occurred. John had access to a large quantity of damaged fruit that was being thrown away, but his father realised it could be made into jam. Another son, William Jnr, was called upon to explore the possibilities. In his home kitchen at Fernleigh in Belmont Road, he experimented before, in 1911, establishing a jam factory in Third Cross Road and planting further orchards to feed the production line.

The following year William won a gold medal in the fruit-bottling section of the Royal Horticultural Society exhibition. The *Daily Telegraph* declared: 'Mr Poupart's collection of 400 bottles of home-grown fruit was the best exhibit of its kind yet seen.' By 1926 orchards had been grubbed up to make way for an expanded production area and over 300 were employed. Harrods, Selfridges and shops around the world stocked their range of Fernleigh Orchards jams.

DID YOU KNOW?
R. D. Blackmore, Victorian author of the historic romance *Lorna Doone*, created an 11-acre market garden at his Teddington home, Gomer House, in 1860 in an area delineated by present-day Station Road and Field Lane. He built up high walls to keep out thieves and aid the cultivation of tender fruit, but his literary talents outstripped his business sense, and the enterprise was not profitable. The house was demolished in 1938 and the garden developed, but is remembered in the street named Doone Close.

The family was also in the dairy business, opening a milk shop, Marsh Farm Dairy, at No. 188 Heath Road, Twickenham, in 1894. Further branches followed at Nos 65–66 London Road and York Street in Twickenham, No. 76 High Street, Teddington, Station Road, Hampton, and in St Margaret's. The milk business was sold to Express Dairies in 1936.

Other farms were added over the years, including Blackmore Farm, on part of which Squires' garden centre in Wellington Road now stands, and Slade Farm, just to the south of Blackmore Farm. Other sons of William Snr established their own businesses: Alfred at Jubilee farm, Whitton; Ernest a gardening tool business at Erncroft Farm and a seed store in London Road; Charles with Poupart's Electric Laundry in Norcutt Road; and Donald with an electrical business at No. 26 London Road.

Meanwhile, John Poupart had taken the rest of the company international. He had hired a buyer called William Ravenhill to import fruit from abroad, beginning with oranges

from South Africa. Rare tropical fruits began appearing in English greengrocers for the first time, including kiwifruit – then known as Chinese gooseberries – uglifruit, a cross between a tangerine and a grapefruit, and the first 'bobby' beans from Kenya.

From 1901 to 1940 the company continued to expand and acquire larger and larger premises at Covent Garden, building up a string of five shops in the Central Avenue and, by 1936, adding all the premises from Nos 107–115 Long Acre. The firm also opened a branch at Spitalfields Market and others around the country at Liverpool, Southampton and Bristol, plus most other major ports, together with depots in Worthing, the Lea Valley and Guernsey, as well as a branch in Cape Town, South Africa.

Gradually, Poupart land in Twickenham was swallowed up by developers. Fulwell Golf Course now covers acres once part of Blackwell Farm and Slade Farm, and Twickenham Stadium plus housing replaced Marsh Farm. The jam factory closed in 1960, and in 1986 the family sold TJ Poupart to Hillsdown Holdings, but the Poupart name lives on. Poupart Ltd is now part of a £80 million turnover company dealing in fruit and vegetables from across the UK and throughout the world.

William Snr and his wife Sarah are buried in the family plot in Twickenham Cemetery, Percy Road, together with their infant son Harold, who died at ten months.

Fish Farming

The stretch of the Thames at Twickenham, Teddington and Hampton was once part of the finest salmon river in Europe. In the fifteenth and sixteenth centuries the quantities of salmon taken at Kingston and Hampton Wick were famous. On into the first half of the nineteenth century, the Thames was in its prime.

Little wonder, then, that a man such as Francis Francis, keen fisherman and angling editor of *The Field* magazine for a quarter century, should choose, in 1851, to move to Twickenham. Sadly however, write J. M. Francis and A. C. B. Urwin in *Francis Francis*: 'During his lifetime the Thames … dwindled to extinction.'

Over-fishing, pollution from riverside sewage and gasworks, and the extensive extraction of water upstream were combining to destroy the Thames. Shortly after Francis moved here, a report on the river stated: 'Salmon have entirely ceased to enter its waters,' and other once plentiful fish such as trout, char and others were becoming rare.

DID YOU KNOW?
Twickenham has two connections with the illegal marriage of the future George IV to the Catholic Maria Fitzherbert. The better-known one is that she retreated to Marble Hill, a grand house on the river, after George rejected her. The little-known connection is that the only clergyman who would marry them, Revd Robert Burn, was given the parish of Twickenham by royal appointment four years after the 1784 wedding. George bitterly regretted forsaking Maria, and appears to have wanted to protect the vicar who went against church and state to marry them.

Fishing the Thames at Teddington Weir a century ago.

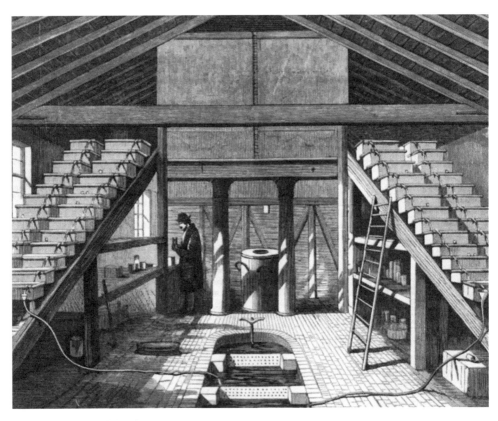

Francis Francis's fish hatchery.

Francis was determined to do all he could to keep the river alive. He was instrumental in having the netting of fish abolished between Richmond and Staines. He helped get fish ladders constructed at weirs to aid salmon in their progress upriver. However, it was not enough. Far more radical solutions were required and, in 1860, Francis went into partnership with the Thames Angling Preservation Society, in a bold mission to restore fish stocks through mastering the then novel and largely untried science of fish farming.

Francis had bought a house called The Firs, in Hampton (now Staines) Road. At the foot of his garden was the River Crane. He built specialised hatcheries in his back garden, in what may have been the first attempts at fish farming in the United Kingdom. The Firs has now gone, replaced by a parade of shops, and Camac Road has spread housing over some of his plot, but there are allotments over the land bordering the river where this remarkable pioneering experiment took place. A similar hatchery was established beside the Thames at Hampton.

As so little was known about rearing fish, this was a hugely risky enterprise, and Francis had to use trial and error. However, success came quickly and between 1861 and 1866 the Hampton hatchery produced 200,000 young fish, including 137,000 brown trout, which were released into the Thames.

A report in *The Illustrated London News* of 19 March 1864 described the Twickenham hatchery constructed by Francis 'for a committee of gentlemen, who had subscribed £100 or £200 for this purpose'. It read:

> The edifice consists merely of a brick and plaster building, 26 ft long by 18 ft wide, covered with thatch – the best roof against both heat and cold. At one end is a huge slate cistern, supplied from the main, and which contains 2,500 gallons of water. The cistern is raised some 6 ft from the ground, and from each end of this double rows of trays, containing the ova, are carried down, one below the other, in regular gradation to the ground ... Some sixty-six of these are now in use, and the apparatus contains at this time about ninety thousand eggs of salmon, salmon trout, great lake trout, common trout and char, some forty or fifty thousand eggs having already been distributed ...
>
> The eggs are placed upon a *grille* composed of fine glass rods ... As soon as the eggs are hatched the fry fall between the bars, and are extracted by drawing a cork from a hole near the bottom of the tray, when they are carefully placed on gravelled trays of larger dimensions.

A brick tank took the young fish after that, before they were transferred outdoors to a pond, where they continued to grow. 'Cut off from a portion of the Crane, which runs through Mr Francis's property, is an artificial stream grated off at each end, and through which the stream flows unrestrictedly for the holding of stock-fish or the further rearing of young fry.'

So productive were Francis's hatcheries that fertilised trout eggs were exported to Australia and New Zealand to enable fish farming to be established there. While Francis had done so much to improve fish stocks on the Teddington and Twickenham stretch of the river, downstream its state continued to be woeful. Francis and Urwin write that 'the number and quality of fish sadly declined to reach a low in the post-Second World War years, when parts of the river downstream were practically dead.'

The Barmy Arms, home of the Francis Francis Angling Club.

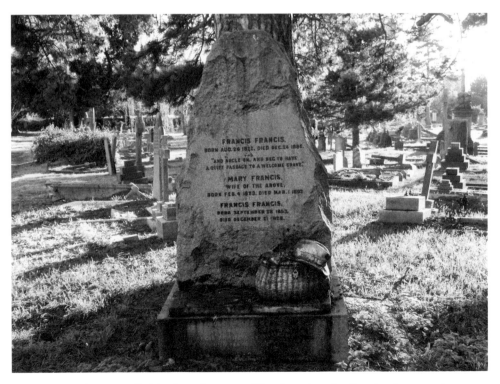

Francis Francis's grave at Twickenham Cemetery. (Charcharoth under Creative Commons)

Upriver, however, the Francis Francis Angling Club were finding better results. The club was set up in his honour in 1906 at the Barmy Arms (formerly the Queen's Head) on Twickenham's Embankment to fish the tidal Thames between Richmond and Teddington from punts moored in traditional style across the river. They found that 'during the dead periods of the river downstream, the Twickenham and upstream tidal reaches ... showed significant catches of roach, bream, dace, gudgeon, perch, carp and tench.'

By 1979 water purity had improved to the extent that the river could be restocked with salmon. A milestone was reached in 1990, when a salmon 1 metre in length – 'the largest fish to be found in the Thames for almost 200 years' according to the national Rivers Authority – was spotted close to Richmond Bridge.

Francis Francis died in 1886 and is buried at Twickenham Cemetery, where his monument contains a sculpture of a creel, (wicker basket) and fisherman's hat and bears an inscription from Izaac Walton's *The Angler's Wish*: 'To angle on, and beg to have, a quiet passage to a welcome grave'.

DID YOU KNOW?
The nave of St Mary's Church in Twickenham collapsed in April 1713. This had been predicted by the new vicar, the splendidly named Canon Prat, who refused to preach in the church, erecting a shelter for services in the churchyard. The congregation refused to believe the church would fall down but, after it did, they realised their new Anglican priest was not such a prat after all.

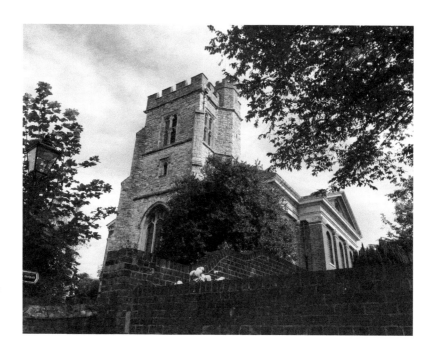

The vicar at Twickenham church had a premonition of disaster.

3. Hampton Court and Bushy Park

We think of Hampton Court as being Henry VIII's palace, and it is true that many significant events in his life and reign took place here. However, the palace that stands today was radically redesigned by later monarchs and bears little relation to the one Henry lived in. So let us look at the lesser-known yet key people, and events, that had the most profound influence on the development of the palace and park.

How Rabbits, Knights and Jerusalem Pilgrims Helped Form Bushy Park

It is hard to imagine that pilgrims and rabbits can have any connection, or that they could have a significant place in the history and development of Hampton Court and Bushy Park, but they did. From 1237 to 1531, a Catholic military monastic organisation called the Order of the Knights Hospitaller of St John of Jerusalem owned a house where Hampton Court Palace now stands and farmed 800 acres of land covering most of modern Bushy Park.

The Knights Hospitaller began as a group that cared for pilgrims to the Holy Land when they arrived in Jerusalem. Their role developed, after the First Crusade at the end of the eleventh century, to providing pilgrims with an armed escort. They quickly grew into a substantial military force, and were charged with the care and defence of the Holy Land.

This was an expensive task, and the Knights had to raise large sums of money to fund their work. Their main base was in Rhodes, but they had branches in many European countries. As much income as possible had to be generated from each of their bases. At Hampton Court, that meant employing new land techniques to maximise profit.

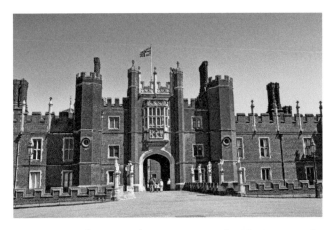 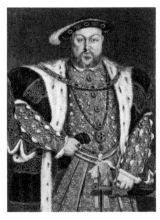

Henry VIII is the monarch most associated with Hampton Court Palace. (Duncan Harris under Creative Commons, The Wellcome Trust)

Rabbit warrens created by the Knights Hospitaller still exist near Chestnut Avenue. (Jonthan Cardy and Ojw under Creative Commons)

With wool in great demand, and prices high, sheep farming seemed to be the answer. However, introducing 2,000 sheep on to land already impoverished through generations of single-crop farming only degraded the soil further. This led to the uncontrollable spread of bracken over the park, which still covers a large area to the east.

With sheep proving unprofitable, the knights turned to rabbits. Huge artificial warrens were created for the animals, signs of which still exist today at Warren Plantation and where Lime Avenue and Chestnut Avenue meet. The warrens provided meat for subsequent occupants of Hampton Court, including Henry VIII, for centuries.

The Fire that Brought Henry VII – and Deer – to Hampton Court

Just before Christmas 1497, fire destroyed Henry VII's palace at Richmond, leaving the king and his royal court without a country home. Looking around for a temporary alternative during rebuilding, his courtiers hit upon the Knights Hospitallers' substantial house just upriver. Temporary it may have been, but Henry needed to indulge his favourite pastimes of hunting, shooting and coursing while here, and so 300 acres of what would become Bushy Park were enclosed and stocked with deer, hares, pheasants and partridges.

In 1515 the Knights Hospitaller leased their house and land to Cardinal Wolsey, who, as Lord Chancellor, was also Henry VIII's chief adviser. Wolsey spent ten years building a palace fit for a king on the site of the knights' house, and had a wall built, enclosing 2,000 acres as a private park. This area covered what are now known as Bushy Park and Home Park. The land was divided by what is now Hampton Court Road.

When Wolsey failed to get the pope to allow Henry to divorce his first wife, Katherine, and enable him to marry his new love, Anne Boleyn, the king took his revenge in part by evicting the cardinal, giving him just four days to clear out. Now the palace fit for a king had a king living in it, and Henry set about radically remodelling the building and comprehensively erasing Wolsey's presence.

In the nineteenth century it was discovered that, hidden beneath a terracotta panel bearing Henry's coat of arms above Anne Boleyn's Gateway in Clock Court, was another

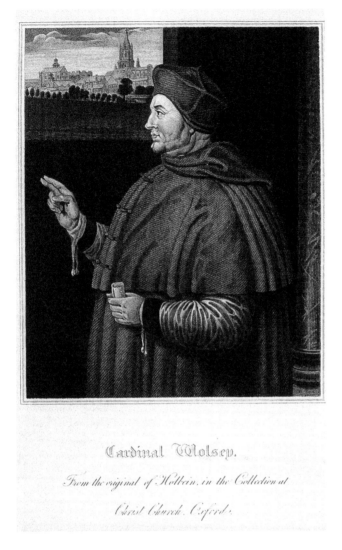

Cardinal Wolsey.
From the original of Holbein, in the Collection at
Christ Church, Oxford.

Cardinal Wolsey.
(The Wellcome Trust)

plaque. This one, featuring a wide-brimmed, tasselled cardinal's hat hovering above two cherubs, bore Wolsey's coat of arms.

How the Need for Ships Gave Bushy Park Its Name

Henry established the boundaries of his parklands in 1536, building walls to the north at what is now Sandy Lane, east to Hampton Wick and west from Hampton Wick to Teddington, creating not just a park for deer hunting, but also a nursery for thousands of acorns that would one day grow into the mighty oaks Henry needed for the ships of his expanding navy.

However, deer and acorns were an unfortunate combination. To prevent the deer robbing the navy of its future warships, thorny bushes had to be planted to protect them and the emerging saplings. By 1604, the name 'Bushie Park' was established.

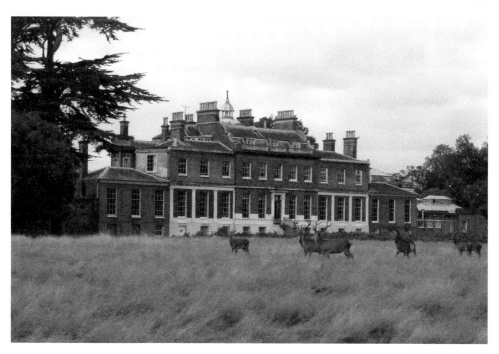

Deer in Bushy Park. (Jonathan Cardy under Creative Commons)

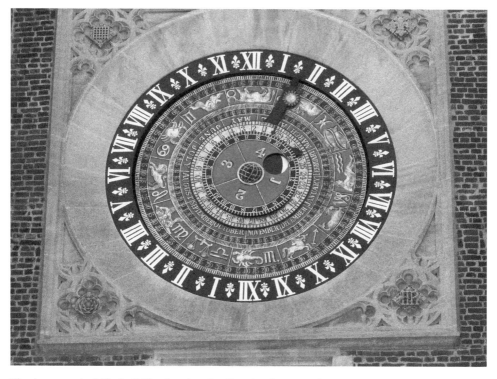

The Astronomical Clock. (Mike Cattel under Creative Commons)

Clock Court. (Carom under Creative Commons)

The Astronomical Clock that Enabled Henry to Navigate the Thames

One problem in navigating down the Thames from Hampton Court to London was that, at low tide, the river emptied, setting up dangerous rapids at London Bridge. What the royal bargemen would love to know before they set out from Hampton Court was the level of the tide at London Bridge, but how could they? In 1540 Nicholas Crazter, who bore the grand title Deviser of the King's Horloges (time pieces), came up with a clock which could do just that, among many other functions.

The clock, which was installed on the gatehouse to the inner court at the palace, has a face 15 feet in diameter, with three separate copper dials on it. The inner dial rotates once per lunar month, and shows the time at which the moon crosses the meridian each day. From that, the tide can be read. The middle dial rotates annually and shows the phase and age of the moon. The outer dial, which also rotates once a year, shows the days, months and the zodiac.

The clock's functions also include showing the hour, month, day of the month, position of the sun, and the number of days that have elapsed since the beginning of the year.

Today, the clock is one of the most prized treasures at Hampton Court, but it proved unreliable and, in 1831, the astronomical dial was removed and the mechanism replaced with one from a 1799 clock from St James's Palace. In 1879 the astronomical dial was

discovered stored away, and a new mechanism made. The clock was fully restored by the Cumbria Clock Company in time for the 500th anniversary of Henry's accession to the throne in 1509.

The bell above the clock is the oldest surviving artefact at Hampton Court. Cast in the fifteenth century, it once hung above the Knight Hospitallers' chapel.

DID YOU KNOW?
The Great Vine at Hampton Court Palace, believed to be the largest and oldest in the world and planted by Capability Brown 250 years ago, has had just ten keepers, two of whom have been women. They are Mary Parker, from 1962 to 1982, and the present keeper, Gill Strudwick.

How Christopher Wren Created a Palace to Rival Versailles

Christopher Wren had always dreamed of building a royal palace and when, in 1689, William and Mary came to the throne, he got his wish. The new monarchs decided to pull down most of the existing Tudor buildings and replace them with a grand baroque palace to rival Versailles, home of William's arch-enemy Louis XIV.

Christopher Wren radically redesigned the palace for William and Mary.
(The Wellcome Trust)

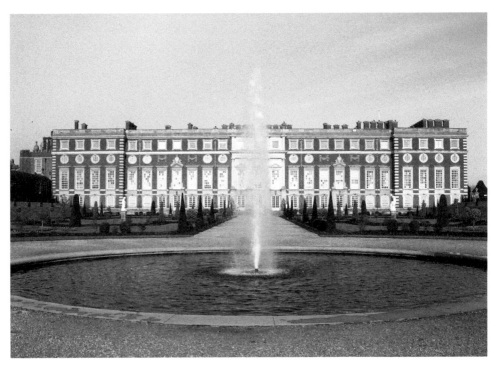

The South Front, designed by Wren. (Mark Percy under Creative Commons)

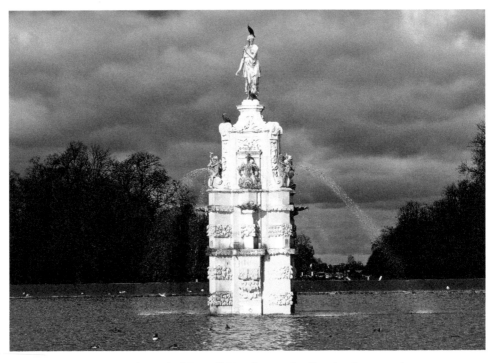

The Diana Fountain in Bushy Park. (Maxwell Hamilton under Creative Commons)

This was Hampton Court's greatest transformation. Wren, as surveyor general, was responsible for much of what we see today, including Fountain Court, the East Front, South Front, the King's and Queen's Apartments, and the Orangery. The Cartoon Gallery was adapted by him so that a series of Raphael cartoons – designs for tapestries depicting the Acts of the Apostles – could be hung there. The cartoons, created in 1516 for tapestries intended for the Sistine Chapel, were removed to the Victoria and Albert Museum in the nineteenth century, and seventeenth-century copies now hang in their place. Wren's Privy Garden design, which had been erased by subsequent layouts, was painstakingly surveyed and excavated and, in 1995, the original plan reproduced.

Wren also laid out Bushy Park in 1699, with the main route to Hampton Court Palace running along Chestnut Avenue from the Teddington Gate, and planted the limes and chestnuts that line it. The statue of Diana, which stands in the round pond on Chestnut Avenue, was originally placed in the Privy Garden by Oliver Cromwell, who, as Lord Protector, occupied Hampton Court at the time of the Commonwealth. It was then named Arethusa. As David Souden and Lucy Worsley write in *The Story of Hampton Court Palace*: 'Cromwell's more puritanical supporters criticised him for having such titillating statues in the Privy Garden. Surrounded by her boys and dolphins, Arethusa stayed, although she would later be moved again, this time to Bushy Park, near the palace.'

Sadly Queen Mary, who had been the driving force behind the transformation, died of smallpox five years after taking the throne and William lost heart in the project. He was to die in 1702 after a freak accident in the park, in which his horse Sorrel stumbled on a mole hill and threw him, breaking his collar bone. The break was reset, but a fatal fever set in.

Christopher Wren, who had stayed close to his project, living at the Old Court House on Hampton Court Green, was given a lease on the house in lieu of unpaid fees by Queen Anne, who followed her sister Mary to the throne. He did not leave office until the age of eighty-six, in 1718, having been surveyor general for fifty years, and lived in the house for the rest of his life.

The Secret to Navigating Hampton Court's Maze

The famous maze was another of William and Mary's creations and may have replaced an earlier one planted by Cardinal Wolsey. The maze, which covers a third of an acre and has half a mile of paths, was conceived as part of a Wilderness Garden, and is the sole survivor of four mazes. It was originally planted with deciduous hornbeam, which was damaged by the huge number of visitors after Hampton Court was opened to the public in 1838, and was replaced with tougher-wearing yew in the twentieth century.

While the maze is generally believed to be notoriously difficult to navigate, there is actually a simple rule that will take you round without error. The secret is to keep in contact with the wall on your right. While the method is slow, because it will take you into and out of dead ends, it means you will be guided to the centre and back out again without once going wrong.

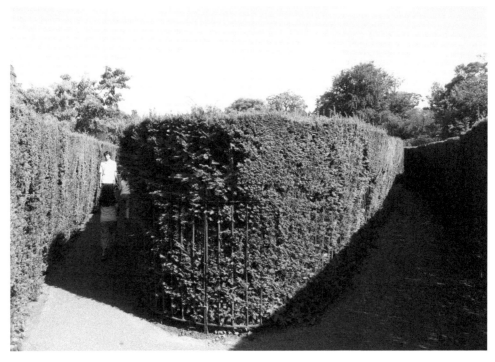

Hampton Court maze, designed for William and Mary. (Kris Arnold under Creative Commons)

Old Court House, where Wren lived until his death. (Spudgun67 under Creative Commons)

The Real Tennis Court. (Maxwell Hamilton under Creative Commons)

The Royal Game: Tennis at Hampton Court

The first tennis court at Hampton Court was laid out for Cardinal Wolsey in 1526 and a succession of kings have played what was known as 'the royal game' here. Henry VIII was a talented player as a young man and spent hours on the court. In 1519, the Venetian ambassador, sounding a little like Elizabeth Bennett seeing Mr Darcy emerge from a lake in a wet shirt, wrote: 'It was the prettiest thing in the world to see him play, his fair skin glowing through a shirt of the finest texture.'

The present tennis court, replacing Henry's, was built in stone for Charles I in 1625 and remodelled for Charles II, the lines of the court being laid out in black marble. The version of the game played here is Real Tennis, in which the ball can be bounced from the roofs of penthouses surrounding the court, as well as being hit directly over the net. Three of the walls to be seen today date from this period, and one – the external wall to the right of the viewing gallery – from Wolsey's time.

The court is still in use today and is the venue for the British Open Real Tennis Championships. The world championships have been played her five times, most recently in 2002, and the court is home to a club with 450 members.

DID YOU KNOW?
William, Duke of Clarence (1765–1837), lived at Bushy House in Bushy Park, first with his mistress, the actress Dorothy Jordan with whom he had ten children, and then with his wife, Princess Adelaide of Saxe Meiningen, who became step-mother to his extensive brood. The duke became William IV in 1830.

A Playground for the People

The first guidebook to Hampton Court was published in 1742 when, for a small sum, the housekeeper would show well-heeled visitors its treasures. This was the beginning of a process in which Hampton Court changed from being an occupied royal residence to a place for public enjoyment.

Queen Victoria opened the floodgates in 1838, during the first year of her reign, when she decreed that the palace and grounds should be thrown open to all her subjects without restriction. The shilling (5p) entry charge was abolished. The novelist Anthony Trollope said, snootily, that it became 'a well-loved resort of cockneydom' and, by 1881, the palace had attracted 10 million visitors.

This was a selfless act for Victoria, for whom Hampton Court and Bushy Park had been a favourite private playground. She continued to come after she had opened them to her subjects, and there are over eighty mentions of visits in her journal. Albert liked to play tennis here, and the queen enjoyed seeing the horses and ponies, some of which she had ridden as a young princess.

After a visit on 3 August 1840 she wrote: 'At about 3 we went in pony phaeton (Albert driving me) to Hampton Court. The Park looked beautiful & Hampton Court itself & the gardens, with its avenues, courts & fountains, looked exceedingly handsome. Albert was very much struck by it & thought it very like Versailles. The heat going there was quite intense. We walked through all the rooms, & looked at the pictures, which are very fine.'

DID YOU KNOW?
A religious conference was held at Hampton Court Palace during the reign of James I, which led to the commissioning of the King James Bible.

4. Grand Houses, Great Minds

Things changed rapidly from the early eighteenth century along the river from Twickenham and Teddington to Hampton as the royal, rich and titled bought up great tracts of land, building a string of grand houses with extensive landscaped gardens.

Facilitating such developments was a Twickenham resident and major landowner called Thomas Vernon. In 1702, Vernon bought the Twickenham Park estate from the Earl of Albermarle, a friend of William III, and land all over Twickenham, including an extensive tract of prime riverfront at Cross Deep, between Twickenham and Teddington, which he leased to those who wished to build. Vernon was incredibly well connected. He was a trader in goods from the Middle East – known then as a Turkey merchant – an MP and a speculator. His brother-in-law was Chancellor of the Exchequer.

Among the great and good who Vernon leased land to was Alexander Pope, who built a villa at Cross Deep. Pope's presence attracted other creative people. Horace Walpole built a remarkable Gothic castle at Strawberry Hill, just above Pope's house, and David Garrick developed a villa at Hampton.

Brian Louis Pearce in *The Fashioned Reed: The Poets of Twickenham from St Margaret's to Hampton Court from 1500* says Twickenham had entered its golden age. 'In the eighteenth century Twickenham was *the* place to be, with Pope dominant in the earlier years and Walpole later in the entry.' Particularly in the 1720s 'the literary activity of the whole kingdom centred for a season or two upon Pope'.

Twickenham Park

By the eighteenth century Twickenham Park, unlike the upstarts now dotting the river, already had an illustrious history going back centuries. In 1592 Sir Francis Bacon, who was studying to be a lawyer at Gray's Inn, fled London because a 'pestilential distemper' had broken out. With several friends he came to live at what was then known as Twitnam Park. The house and its 87 acres were just across the river from Richmond Palace, Elizabeth I's favourite royal residence, in Richmond.

Bacon, born in 1562 and the son of a senior courtier, had met Elizabeth while at Trinity College, Cambridge. She was impressed by his prodigious intelligence. In 1593 the queen granted Bacon the lease of Twickenham Park. He entertained her here and presented her with a sonnet in praise of her then favourite, the Earl of Essex. He loved the house, writing in 1594 that: 'One day draweth on another, and I am well pleased in my being here, for methinks solitariness collecteth the mind as shutting the eyes doth the sight.'

Bacon was a polymath and genius – a philosopher, scientist, statesman and poet. Some scholars argue that Bacon wrote *Love's Labour's Lost*, rather than Shakespeare, and did so at Twickenham Park. Money troubles led Bacon to sell Twickenham Park to Lucy Harrington, Countess of Bedford. Lucy was one of the most influential women in England,

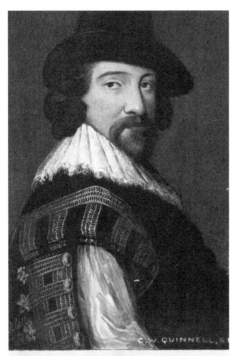

· SIR · FRANCIS · BACON ·

Sir Francis Bacon, Elizabeth I's protégé and neighbour.

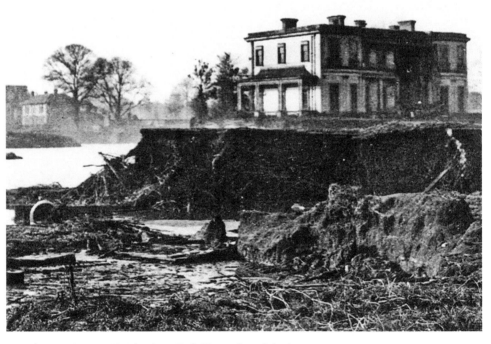

Gravel extraction saw Twickenham Park House demolished.

an accomplished hostess and patron of the arts, who appeared in masques designed by Ben Jonson and Inigo Jones.

> DID YOU KNOW?
> The father of Alexander Pope's landlord, Sir Thomas Vernon, is believed to have dug up a weeping willow from beside the Euphrates river and introduced the species to this country, cultivated it, and sent cuttings around the world, including to Catherine the Great of Russia. One sapling was planted in Pope's garden, and a log cut from it is now in his grotto.

She replaced the house and created a remarkable Renaissance garden. Lucy's garden inspired John Donne to write a poem, 'Twicknam Garden', about it. It is a sonnet in which a love-struck protagonist seeks solace in the garden of a beautiful and aloof lady to whom he is in thrall. Lucy was a close friend of Queen Anne, subject of the award-winning 2018 film *The Favourite,* and her Lady of the Bedchamber.

The Twickenham Park estate was broken up in the 1820s, and an array of new villas built, including one called Twickenham Park House. By the twentieth century that house had suffered a sad decline. It had become a school, an auction house and finally the offices of the Thames Sand and Gravel company. That firm extracted gravel from the grounds until all that was left was the house, standing on an island. In 1929 it too was demolished and the final gravel removed. The only element still standing are brick walls surrounding the gateway in Ravensbourne Road.

Pope's Villa and Grotto at Twickenham

Cross Deep was an area of artisans' cottages on the river between Twickenham and Teddington when the poet Alexander Pope, best known for *The Rape of the Lock*, and translations of Homer's *Illiad* and *Odyssey*, arrived with his mother and now-elderly childhood nurse in 1719.

His landlord, Thomas Vernon, had leased him the land on which three cottages stood. Pope also rented 5 acres of ground on the other side of the road to create a garden.

He immediately set about building himself a grand house – although he referred to it as a mere villa. In a letter in 1720, Pope wrote 'my building rises high enough to attract the eye and curiosity of the passenger from the river, where, upon beholding a mixture of beauty and ruin he inquires what house is falling or what church is rising?'

Pope's plot was bisected by a road, with his house facing the river and his garden on the other side. He began to create a grotto – a series of caverns decorated with shells, rocks and minerals – beneath the house, from the rear of which a tunnel ran under the road, linking it to the garden. Guests arriving by boat would enter the grotto and pass through this strange subterranean world, and on through the tunnel to emerge into the bright garden. The house and garden are now lost, but the area bounded by Popes Grove, Grotto

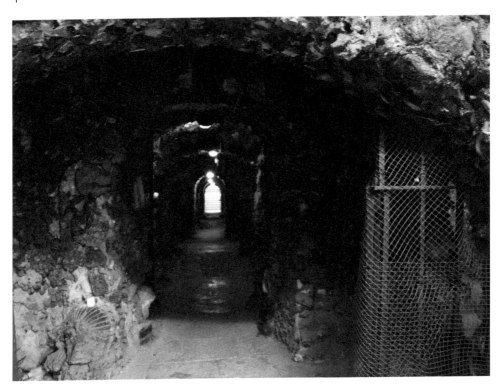

Pope's Grotto today.

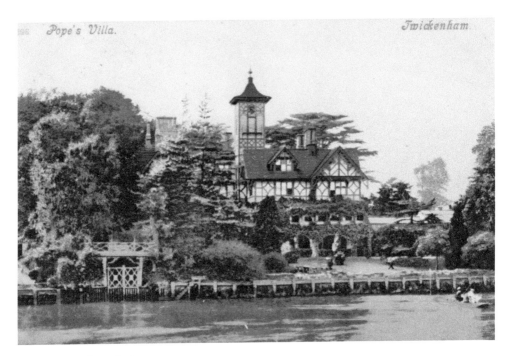

Pope's villa early in the last century.

Alexander Pope with one of his aphorisms.

Road and Radnor Road roughly outline the area. The grotto – much neglected over the years – remains and is the subject of an extensive restoration project.

In Pope's time the grotto was a remarkable creation. It included 'a spring of the clearest water, which falls in a perpetual rill, that echoes thru' the cavern day and night'. There was also said to be a *bagnio* or bathing cavern in the north chamber, although no trace of it survives.

In the summer of 1725 Pope wrote: 'From the river Thames, you see thru' my arch up a walk of the wilderness to a kind of open temple, wholly composed of shells in the rustic manner; and from that distance under the temple you look down thru' a sloping arcade of trees, and see the sails on the river passing suddenly and vanishing, as thru' a perspective glass. When you shut the doors of this grotto, it becomes on the instant, from a luminous room, a camera obscura, on the walls of which all the objects of the river, hills, woods, and boats, are forming a moving picture in their visible radiations.'

From 1739, inspired by a visit to the Hotwell Spa in the Avon Gorge, he transformed the grotto, covering its walls with 200 purloined geological features including a stalagmite from Wookey Hole and chunks of basalt from the Giant's Causeway. There were crystals, including ones known as Bristol and Cornish diamonds, marble and alabaster.

Today, some will be aware of Pope through *The Rape of the Lock,* his satire on epic poetry in which the relatively trivial matter of a besotted suitor snipping a lock of a woman's hair without her consent becomes a huge breach between their two families.

Many more will be aware of him less by name than through the many aphorisms – pithy observations containing a general truth – which he coined. They include: Fools rush in where angels fear to treat; Blessed is he who expects nothing, for he shall never be disappointed; To err is human, to forgive, divine; and A little learning is a dangerous thing.

Pope also wrote 'Who breaks a butterfly upon a wheel?' a phrase used by William Rees Mogg, as editor of *The Times*, to condemn the jailing on drugs charges of Rolling Stone and Richmond resident Mick Jagger.

Pope had many enemies, not a few acquired through the viciousness of his attacks on those he disagreed with. He would never go for a walk without two loaded pistols and his dog Bounce, a mastiff. Bounce once saved his master's life. In the middle of the night Pope was awakened by the sound of someone in his room. Peering through the curtains around his bed he saw a man with a knife in his hand coming towards him. Pope screamed for help, Bounce leapt at the man and pinned him to the ground. The attacker was a valet who Pope had hired that day, and to whom his dog had taken an instant dislike.

Pope, who died in 1744, is buried in St Mary's Twickenham in a modest, virtually anonymous grave by the chancel steps, under a stone marked simply 'P'. The church also contains a memorial to Pope's parents on the east wall of the gallery but, while it bears both of their names, his own inscription is merely the words '*et sibi*' (indicating he wished to be remembered as a humble son), his age and the year of his death. Unfortunately, his age is given incorrectly as fifty-seven; in fact he died nine days after his fifty-fifth birthday. In 1761 a monument to Pope was erected on the north wall of the gallery.

Pope's villa was demolished in 1807 by the then owner, Baroness Howe. According to Historic England: 'Irritated by the number of people who still visited the site in memory of Pope, she removed most of the decorations that adorned the Grotto and further altered the garden.' In the 1930s a chapel, for the convent school which then occupied the site, was built in front of the grotto's entrance from the river.

Since 2010 the Pope's Grotto Preservation Trust has worked to conserve what remains of the grotto, and a £200,000 programme of cleaning and restoration should be completed in 2020. Today, it is possible once again to visit Pope's creation, and tours are heavily oversubscribed, just as they were in Pope's day.

DID YOU KNOW?
Sir William Stanhope, who bought Pope's villa in 1745, later bought a house diagonally across Radnor Road at the foot of the garden. Stanhope had a cave dug in the corner of the garden of this house and linked it via a tunnel under the road to Pope's garden. Stanhope was proud of supposed improvements he made to Pope's celebrated garden, and placed a plaque above the now blocked-up entrance to the tunnel in which he claims, in verse: 'Stanhope's plans unfold the soul of Pope'. In the cave – today only accessible from a private garden – he placed a marble bust of Pope, and another of himself.

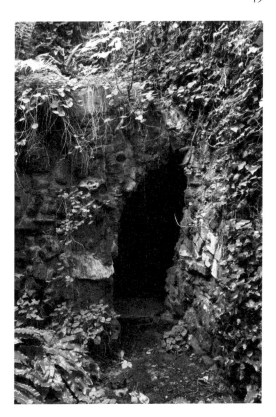

The hidden entrance to Stanhope's Cave, and a peacock design on the wall.

Horace Walpole, Strawberry Hill House

Professional architects dismissed Horace Walpole as an amateur with questionable taste, but the house he created spawned a revolution in architecture. Strawberry Hill House was known as Chopped-Straw Hall when he bought it, after the original owner, a former coachman to the Earl of Bradford, who was said to have made his fortune selling Bradford's hay to the public and feeding his horses on cheap straw, investing the proceeds in property.

Walpole, novelist and youngest son of prime minister Sir Robert Walpole, declared: 'I am going to build a little Gothic castle at Strawberry Hill.' He spent the rest of his life doing just that, spawning a highly influential style: Strawberry Hill Gothick. His creation inspired him to write *The Castle of Otranto*, the first modern work of horror fiction, progenitor of Mary Shelley's *Frankenstein* and the works of Bram Stoker.

It was three years after Alexander Pope's death that Walpole (1717–97) came to Strawberry Hill, but he had met Pope – whose house was just 200 yards downstream of the site of his own – at the age of eight while on a visit to Twickenham. He was very conscious of the great men who had come before him.

At Strawberry Hill he wrote 'Pope's ghost is just now skimming under my window by a most poetic moonlight.' He wrote a poem, 'The Parish Register of Twickenham', which mentions Pope and Sir Francis Bacon among other 'Statesmen, bards and beauteous dames' and paints Twickenham as a very special place:

> Where silver Thames round Twit'nam meads
> His winding current sweetly leads;
> Twit'nam, the Muses fav'rite seat,
> Twit'nam, the Graces' lov'd retreat.

 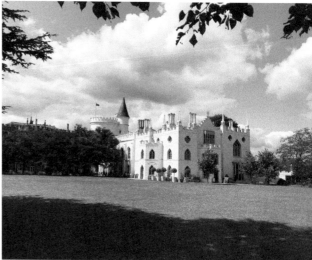

Above left: Horace Walpole. (Lewis Walpole Library)

Above right: Strawberry Hill House.

Harptree House,
Walpole's hiding
place across
the road.

John Iddon, in *Strawberry Hill and Horace Walpole,* captures the essence of what he did
with the house, his summer retreat for fifty years:

> Walpole coined the word 'serendipity', the idea of encountering felicitous surprises, and
> the completed 'castle' achieves this: a winding route creating theatrical effects; outside
> views and inside light interacting; and the gradual emergence from monastic dark to
> more open, light and opulent spaces beyond. All give the impression of moving through
> an ancestral pile added to by generations of Walpoles.

Like Pope's villa, Strawberry Hill House suffered from many decades of neglect, but
a £9 million renovation is complete and visitors once more flock here, as they did in
Walpole's day. In 1763, Walpole complained to a friend: 'I have but a minute's time in
answering your letter, my house is full of people, and has been so from the instant I
breakfasted, and more are coming – in short, I keep an inn; the sign, the Gothic Castle
... my whole time is passed in giving tickets for seeing it, and hiding myself when it is
seen – take my advice, never build a charming house for yourself between London and
Hampton-court, everybody will live in it but you.'

DID YOU KNOW?
There is a tragic story associated with the Walpole Oak, the oldest tree in the
gardens of Strawberry Hill House. A servant who stole silver from his master,
which he hoped to sell to pay off a gambling debt, hanged himself from the tree
when his theft was discovered.

Walpole often fled, hiding out in his 'cottage in the woods' across the road, later named Harptree House, when guests were being shown over Strawberry Hill. Harptree has a Saracen's head over the door, echoing the crusader theme found throughout Strawberry Hill House, and has been extended since Walpole's time.

The story of the destruction of Walpole's vision is less well known. The house contents were sold in a fit of spite by the dissolute husband of a subsequent owner, in what became known as the Great Sale.

Lady Frances Waldegrave had inherited Strawberry Hill House through her marriage to John Waldegrave, grandson of Walpole's great niece. When John died, after just a year of marriage, Frances married his brother, George, the 7th Earl. The marriage would have been illegal in England, so the couple travelled to Gretna Green for the ceremony.

Within seven months, George was sent to prison for a violent, drunken attack on a local policeman. *The Spectator* of January 1841 reported:

> In the Court of the Queen's bench, on Monday, the Earl of Waldegrave and Captain William Duff were brought up for sentence, for an outrageous assault on Wheatley, a policeman at Hampton Wick. On the 4th of June, a party, consisting of the two prisoners and four others, had dined together at Lord Waldegrave's house Strawberry Hill, drinking freely of wine; and had then gone in a fly to Kingston races. They stopped in a village on their way back at eleven at night, and alighted. One of them, believed by the police to be Lord Waldegrave, tried to open a house-door: upon which Churchill, a police sergeant, interfered.
>
> 'A conversation followed, at first friendly, but becoming abusive and one of the drunken hoorays tried to unbuckle the reins of the sergeant's horse. He told the constable to arrest the man, while he went for assistance. Wheatley seized Lord Waldegrave; who was violently rescued: the party, except Duff, who ran away, re-entered the fly. As it drove off, Wheatley grabbed one of them by the leg and was struck on the head repeatedly with a stick, and kicked: he fell; the wheel of the carriage passed over his legs. He was found bleeding and senseless on the road, was confined to bed for several weeks and will never recover from the shock to his brain.

Waldegrave and party pleaded guilty. He was sent to the Marshalsea prison for six months and fined £200, but was allowed to take his wife and servants to prison with him.

The following year George, heavily in debt and tired of Strawberry Hill, auctioned the entire contents, the sale lasting thirty-two days. When he died in 1846, he left the now derelict house to his wife. Frances married twice more and acquired the wherewithal to restore Strawberry Hill House. At her death the house was sold, first to a hotel company

DID YOU KNOW?
When Horace Walpole's cat drowned while trying to catch goldfish in his pond he commissioned Thomas Gray, of 'Elegy' fame, to write a poem in its memory.

and later to the Catholic Education Council, and became a teacher training college. It is now owned by St Mary's University.

Garrick's Villa at Hampton

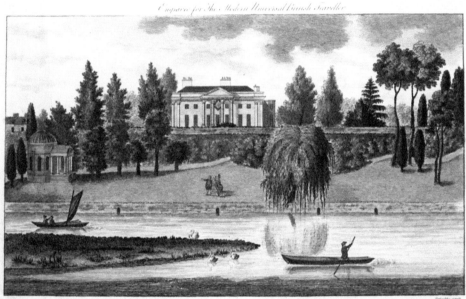

A View of the SEAT of the late DAVID GARRICK Esq at Hampton, with a prospect of the Temple of Shakespeare in the Garden.

Above: Garrick's villa in a contemporary engraving.

Right: David Garrick, greatest Shakespearean actor of his age.

Garrick's temple to
Shakespeare.

England's greatest actor manager moved to Hampton in 1754, towards the end of a stellar career on the stage, to escape the pressures of theatrical life. By now David Garrick had helped re-establish Shakespeare's reputation, introduced a more naturalistic style of acting to the English stage, and managed the Drury Lane Theatre for thirty years.

Garrick (1717–79) commissioned the Adam brothers to create Hampton House (now known as Garrick's Villa) from a row of cottages and consulted Lancelot 'Capability' Brown about the grounds. He created a grotto-like tunnel beneath the road to his Thames-side garden, where he built an octagonal temple to Shakespeare in which to house his mementoes of the bard. Garrick was given a cutting of a Mulberry tree grown by Shakespeare and planted it alongside his house. It is still there today.

In 1902 the house was threatened with demolition when the London United Tramway Company bought it, but was saved when the general manager, Clifton Robinson, decided to live there. Tram tracks were laid up to the door. During the Second World War, Shakespeare's Temple was used as an air-raid wardens' post. Today the temple has been restored and the house converted into apartments.

DID YOU KNOW?
Mo Farah, our most successful track athlete in modern Olympic history, trained at St Mary's University, which now owns Strawberry Hill, from 2001 to 2011.

Mo Farrah trained at St Mary's University, Strawberry Hill. (Tim Hipps under Creative Commons)

5. Eel Pie Island, the South's Answer to The Cavern Club

Today, Eel Pie Island is a quiet backwater best known for its many artists' studios. In the 1960s, however, the island's Eel Pie Hotel rivalled The Cavern in Liverpool as a cauldron for emerging English pop music. Yet it is far less famous.

The club played a central role in the birth of British rhythm and blues, which was just as vital as the emergence of the Liverpool Sound. Here, The Rolling Stones had a weekly residency, and Rod Stewart was discovered. David Bowie, Eric Clapton, Jimmy Page, Jeff Beck and The Yardbirds learned their craft at the Eel Pie Club and other local venues. They took gritty R&B, fused it with electric rock and roll and began to define a sound that would sweep the world.

Yet it all began in a most unexpected way: in Snapper's Choice, a junk shop in Kingston owned by Michael Snapper. Working in the shop was a man in his late twenties called Arthur Chisnall, who aspired to be a social researcher and had a keen interest in youth sub-cultures. He noticed that art students were buying up old and deeply unfashionable trad jazz records. He sensed a trend, got to know his customers, and asked a searching question: what was missing from their lives? Michelle Whitby, in *The British Beat Explosion*, writes: 'He concluded that what they most needed was a place to get together, make a little noise and dance to it.'

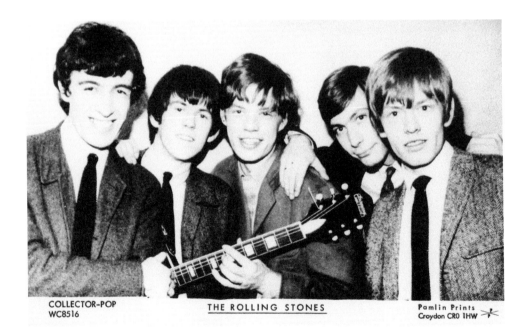

COLLECTOR-POP
WC8516

THE ROLLING STONES

Pamlin Prints
Croydon CR0 1HW

The Rolling Stones had a residency at the Eelpiland club in 1963. (Pamlin Prints)

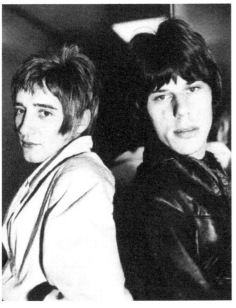

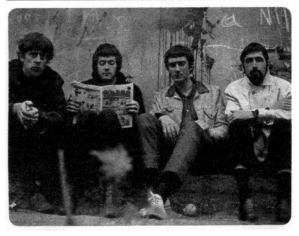

Above left: Rod Stewart, pictured with Jeff Beck, another regular, got his big break at the club.

Above right: Eric Clapton played here with John Mayall's Bluesbreakers and later Cream.

It happened that Michael Snapper also owned most of Eel Pie Island, a place of wooden chalets and boatyards reached via a rowing-boat ferry from Twickenham. Among Snapper's properties was the once-grand but now dilapidated Eel Pie Island Hotel. Snapper was struggling to find a use for the place, which had once been hugely popular with Londoners who would come upriver on paddle steamers to enjoy afternoon tea in its grounds, and to dance on its huge sprung dancefloor. By then, the crowds no longer came and a tired trio played foxtrots for half a dozen shuffling couples.

DID YOU KNOW?
Eel Pie Island got its name in the early sixteenth century when Mistress Mayo, who lived there, became famous for delicious pies containing eels caught in the Thames. When Henry VIII tasted one he was so impressed that he insisted the first pie baked each season should be sent to him at Hampton Court Palace.

Snapper had applied to turn the hotel into a casino, but been turned down. So, when in 1956 his young employee suggested turning it into a trad jazz club he was prepared to give it a go.

Chisnall didn't do it for the music. Though he quite liked the trad jazz acts such as Kenny Ball and Acker Bilk that he booked in the early years, he could take or leave the R&B bands he turned to in the early sixties, when musical tastes among the young changed. What really interested him was the opportunity the Eel Pie Hotel offered him to conduct a social experiment: to create an outreach project designed to draw in and help wayward young people.

The music was no more than a means to that end. As Leslie T. Wilkins, Research Professor at the State University of New York, explained in his paper 'Unofficial Aspects Of A Life In Policy Research':

> Arthur did not go out to find his problem kids, he wanted to attract them to him. His clientele would identify themselves if he provided the appropriate kind of bait. This had to be such as that it would be taken only or mainly by the kinds of youth who needed help which he was able to organise.
>
> He provided a stage where bands which were popular with the youth culture could play ... He wanted it to be the kind of place where a teenage girl who had just had a row with mum would think of going for a bit of real sin.

Yet Chisnall designed a controlled environment in which such people were safe. In consultation with the police, Chisnall formed a proper club with paying membership. Anyone who wanted to listen to the music had to pay 2s 6d (12.5p), fill out a form, and receive a Passport to Eelpiland with their name on it. This meant Arthur knew who they

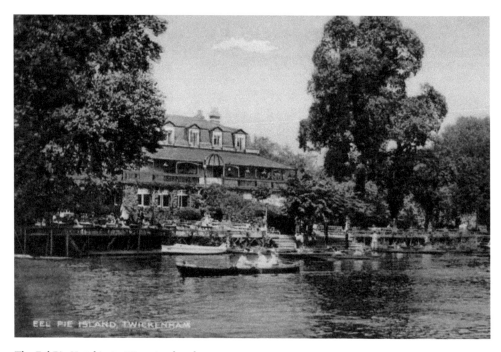

The Eel Pie Hotel in its Victorian heyday.

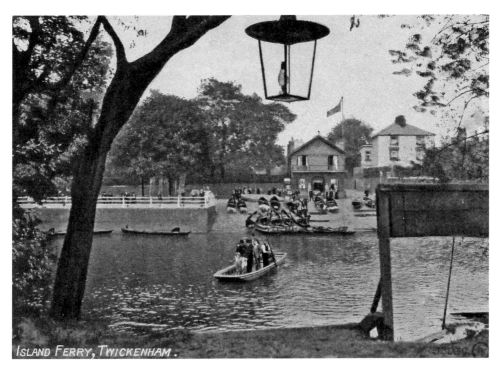

Before the bridge was built the ferry was the only way to the island.

Michael Snapper, owner of the club, had the bridge built in 1957.

were, and he built up a team of supportive adults – often art students, but also including young social workers, doctors, psychologists, a vicar and a policeman – who would look out for the vulnerable. Many had themselves first come to the island as vulnerable teenagers. Wilkins goes on:

> The lone girl arriving would have to join the club and give a name and address. As she was passed into the dance hall, Arthur would signal unobtrusively to one of his selected young folks. The person so signalled was to keep an eye on the new entrant and ensure that no real harm came to her, but certainly to stay out of the way unless occasion to act should occur. These helpers were not obviously trying to be helpful but rather to act as guardians of extreme boundaries of harm.

Arthur would intervene in such a way that none of these vulnerable people realised it was an intervention. 'He would often introduce persons with a phrase such as, "I think you will find X fun to be with ... He/she is, like you, interested in..." However, the introductions would involve one of his workers.'

Arthur Chisnall changed many lives. Michelle Whitby, who got to know Arthur and now runs the Eel Pie Island Museum in Twickenham, writes: 'Chisnall told me "I wanted to be involved with the community but not in a position of authority; I wanted to observe and interact on a practical level".'

The tabloids portrayed the club as a den of iniquity, but in 1962 the *Times Educational Supplement* said that what Arthur had actually done was to create 'a meeting place for intelligent, thoughtful but academically deprived young men and women'. He got some of them into further education. Michelle Whitby writes: 'He got a couple of dozen into Coleg Harlech in Wales, where he had studied Social Science and which was set up to provide learning opportunities to all, regardless of background, and at other colleges.'

The Music

So it was just by chance that Eel Pie Island became one of the key venues in this area of South West London, a shortlist that also included the Crawdaddy Club over the river at the Station Hotel in Richmond and the Ealing Club, a few miles north, which together became a remarkable cauldron of musical creativity.

According to *The British Beat Explosion*, this area was

> On a par with the Memphis of Elvis and Sun Records. More so than Liverpool, more than California's surfing coast, even more than New York in the '80s, Twickenham/Richmond influenced the course of rock music for the next fifty years. Van Morrison, Brian Jones, Mick [Jagger] and Keith [Richards], Rod Stewart, Pete Townshend and Eric Clapton ... were galvanised by the sounds of Chuck Berry, Bo Diddley, Muddy Waters, Howlin' Wolf, Jimmy Reed, John Lee Hooker, Elmore James, Willie Dixon and Robert Johnson and became the UK prophets of a new electric blues ... Jim Hendrix, Led Zeppelin, Jeff Beck, Queen, ELP, Deep Purple, Fleetwood Mac, Moody Blues followed, all rooted in the 1963–65 Twickenham/Richmond scene.

Bands played on Saturdays, Sundays and Wednesdays on a small alcove-shaped stage at one end of a huge hall, with a long bar against one wall. Up a steep staircase above the stage was a band room. At the other end of the hall was the Rockers' Bar, a small room with a juke box.

The Rolling Stones

Most of the members of The Rolling Stones were regulars in the audience at Eel Pie Island, but were not playing here. Instead the band, the most popular in the area, had a Sunday night residency at the Crawdaddy Club at the Station Hotel in Richmond. Then, in 1963, Brian Jones called Arthur Chiswell to say that they'd love to play the club before they got too famous. They held a Wednesday-night residency from April to September, at £45 a gig.

Bill Wyman said of their first appearance: 'The place, like a huge barn, held a maximum of 800 and we drew about 300, many of them diehard fans who had followed us from Richmond, Ealing and Windsor. The feeling in the band around this time was great – an optimism that something good was about to happen.'

He was right. In June their debut single, a cover of Chuck Berry's 'Come On', went to No. 21 in the charts. Arthur Chisnall said of their final gig on 25 September, 'If we'd realised just how big they had got we would have cancelled it. Never mind the hotel, the whole bloody island was overflowing ... there were queues back over the bridge. In theory we should have stopped the music and told everyone to leave but we would have been torn to pieces.'

The Stones were about to go on tour with Bo Diddley, Little Richard and the Everly Brothers, and Jagger signed off saying they hoped to be back. In fact, they never were. Fame got in the way until 2003, when the Stones were the first band to play Twickenham Stadium.

Rod Stewart

Rod Stewart, who also came initially to the Eel Pie Hotel as a punter, remembers first seeing the Stones. In an interview with the *Daily Express* about the 2015 documentary *Rock 'n' Roll Island* he said:

> Eel Pie Island was a big hang-out for me. I was 18 and going out with a girl called Sue Boffey. She had a friend called Chrissie who wanted us to go and see her boyfriend's band. Chrissie's second name was Shrimpton (the younger sister of model Jean) and her boyfriend was Mick Jagger. The night we saw Mick with The Rolling Stones, they all sat on stools, wearing cardigans, singing blues numbers.
>
> The singer could hold the room's attention and I remember thinking that the band was great. But I had the nagging feeling that I could do that. I could draw a few people around with a guitar on the beach so why couldn't I take it up a level and enthral an audience on stage?

Rod got his chance when, sitting at Twickenham railway station one night on his way home from a gig, he was overheard by Long John Baldry playing Howlin' Wolf's 'Smokestack Lightenin'' on his harmonica. On the train they got talking.

The Eel Pie Island Museum.

Keeping the musical heritage of the island alive.

Baldry was one of the big early stars of Eel Pie Island, playing in Cyril Davies' All Stars. Cyril was a blues harpist who, according to Jimmy Page, another regular performer, 'was the first man to emulate the sound of the Chicago Blues Band in England with his harmonica electrified ... [setting] a standard which helped many groups such as The Rolling Stones, The Yardbirds and John Mayall's Bluesbreakers'.

Baldry had just taken over Cyril Davis's band, after Cyril collapsed during a performance on the island and died, at just thirty-one, from inflammation of the heart. Baldry was about to relaunch the band as the Hootchie Coochie Men, and asked Rod to join as a singer, on £35 a week: 'A fortune in those days', according to Rod.

Baldry later introduced his new vocalist on stage at Eel Pie with 'Tonight, ladies and gentlemen, we are privileged to have a guest singer with a truly outstanding blues voice. I give you Mr ... Rod Stewart.'

David Bowie
David Bowie was still Davie Jones when he first appeared with the Mannish Boys at Eel Pie in August 1964. He performed regularly through that year and, on the liner notes to his album *Pinups*, he wrote: 'These songs are among my favourites from the '64–'67 period of London. Most of the groups were playing the Ricky-Tick (was it a 'y' or an 'i'?) – Scene club circuit (Marquee, eel pie island la-la) ... Love-on ya!'

Pete Townshend
Pete Townshend went to Eel Pie Island a lot, but The Who only played there once, in October 1965. Townshend said: 'Setting foot on the island there is a sense of calm, but also a rather spooky feeling ... I've never wanted to spend more than a few moments there. The Who performed there once shortly after I bought my house [at Twickenham] ... I had a boat moored there from 1973. I used it to go to The Who's studio in Battersea while recording Quadrophenia.'

Eric Clapton
Eric Clapton first played the island as a member of John Mayall's Bluesbreakers. He said of it: 'It was a fantastic place, but I do remember the trouble we had trying to haul John Mayall's Hammond organ across that bridge.' He also went there first to listen to the music: 'I started to go there for the jazz and I remember that floor. We'd stand in the middle and it would bounce up and down so much you didn't even have to dance, it would go at least six or seven inches up in the air'.

Arthur Chisnall has said: 'Cream played one of their earliest gigs on the Island, with Eric Clapton, Jack Bruce and Ginger Baker' in August 1966.

The End
On 4 September 1967 the venue was forced to close. Michael Snapper was charged with allowing 'public dancing' in breach of his licence. The prosecution described the club as 'dirty, dimly lit with a foul atmosphere and music so loud even a shouted conversation is impossible'. Expensive improvements were demanded, but Snapper could not afford them. In 1969, the hotel reopened briefly as Colonel Barefoot's Rock

Today the island is a peaceful, quirky backwater.

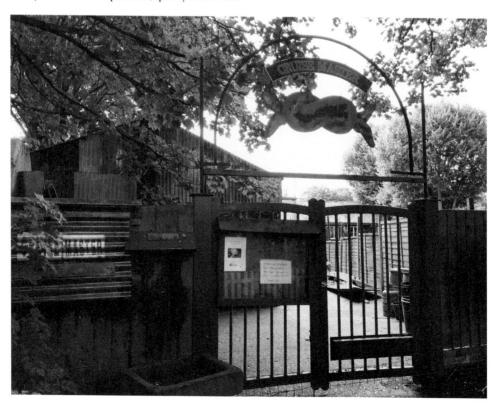

Garden, with gigs by Black Sabbath, The Edgar Broughton Band, Stray, Atomic Rooster, Genesis and Hawkwind.

Those gigs petered out, and the abandoned hotel became a commune, squatted by a mix of 100 hippies, anarchists and misfits. It was declared unfit for human habitation in November 1970. The following year fire broke out and the building was destroyed. Today, houses stand on the site it occupied, on the far side from Twickenham Riverside. Michael Snapper was bought out by Eel Pie leaseholders, who now control the island.

Eel Pie's musical heritage is honoured in two ways in Twickenham: through the Eel Pie Island Museum and at the Cabbage Patch pub, where the Eel Pie Club holds gigs. Arthur Chisnall died, aged eighty-one, in 2006.

DID YOU KNOW?
Trevor Bayliss, inventor of the clockwork radio and Eel Pie Island's most famous resident, described it as '120 drunks clinging to a mudbank'. He said of the club: 'Well we had the sex and the rock and roll but there wasn't much in the way of drugs. We went there for the music and kinfolk ... I was into the jazz and I remember going over there one night and hearing an awful racket which turned out to be the Rolling Stones!' Trevor died in 2018.

6. How Twickenham Became the Home of Rugby

Building a stadium at Twickenham was a key part of the Rugby Football Union's (RFU) attempt to build a successful national team. Billy Williams and William Cail chose the market garden site, known as the Cabbage Patch, on which the stadium was built in 1909, but why did they reject an alternative, far more accessible site? Is there anything in the rumour that Cail bought land secretly owned by Williams in some sort of back-hand deal?

The academic Edmund Harris has investigated the situation in *Twickenham Rugby Ground 1906–1910: A Grand Gesture*. William Cail was the RFU's treasurer, responsible for investing union funds, and Billy Williams was chairman of the New Ground Committee, tasked with finding a site.

The original plan was to buy 10 acres on the Erncroft Estate, situated just to the north of Twickenham town centre, with access from the London Road with its vital tram link to London, and close to Twickenham railway station.

However, when it came to it, the money was not there. Cail's investment of £6,000 in Government Consols would yield only £4,900, leaving them £1,500 short of the total they needed. Cail and Williams had a choice: they could either abandon plans for a ground of their own, or find a cheaper site – or one where full payment was not needed up front. At this point, buying a site on the more distant Fairfield Estate was raised. As we saw in chapter 2, this area was once farmed by William Poupart.

According to the memoirs of Alf Wright, former RFU archivist and assistant secretary, it was Billy Williams who 'suggested that the union might like to buy it'. Wright added that although a 'vocal minority thought he was mad to make the suggestion... [it] did not stop Billy'. Seven weeks later the deal was completed.

No public transport served the site, which was prone to flooding from the River Crane, and the only access was on foot, or via private transport, along a service road between rows of newly built houses. *The Thames Valley Times* slammed the decision, saying that the selected site did not represent the best choice, claiming that the terms on the original site were 'almost identical' and that when they had questioned the arrangements surrounding the purchase they had been 'met with a stony silence'.

So did Billy Williams own the land? No documentary evidence has been found, but Harris presents anecdotal evidence that he did. He quotes oral testimony from a great nephew, also called Billy Williams, who said: 'George Williams, my uncle, farmed the land ... they leased all that land ... that was Billy Williams' only ground ... he leased the ground to my grandfather ... he negotiated and then eventually it was all passed over to Billy Williams – the owner – to do the completion of the business.'

Harris notes: 'the very suggestion that the Rugby Football Union purchased land directly or indirectly from the chairman of its New Ground Committee is the stuff of scandal. Even if Billy Williams was the owner and the land was transferred in some form of non-profit bequest, questions would have been asked. Quite possibly they were, which

The iconic statue in Rugby Road. (Maxwell Hamilton under Creative Commons)

The impressive modern stadium.

might explain the local press having been met with a 'stony silence' from the union. One newspaper may have been hinting at a sneaking suspicion when it recounted Billy Williams personally picking all of the apples from the orchard 'to sell to help raise the purchase money for the ground'.

Harris adds that, according to Cail's later autobiographical notes, the initial payment in 1907 was for just £3,500 and the full sum owed was not paid until 1913. He concludes that 'Billy Williams would appear most likely to have been the vendor'.

What is certain is that the ground has become a resounding success. Harris says: 'Whilst it took 60 years to get the pitch right, and still the question of access haunts it, Twickenham stands as a testament to William Cail's grand gesture, which ... sow[ed] a new democracy for the England Rugby Union game on Billy Williams's unpromising cabbage patch.'

DID YOU KNOW?
Many stars have lived out their final years at Brinsworth House, a residential and nursing retirement home for theatre and television performers in Staines Road, Twickenham. The Royal Variety Charity runs the home, which has forty bedrooms plus a library, bar and – of course – a stage, and is set in 3 acres of gardens.

Former residents are buried in Twickenham Cemetery, where there are currently 291 memorials to stars including Hilda Baker, Charlie Drake, Alan Freeman, Thora Hird, Kathy Kirby, Mick McManus and Norman Wisdom.

The Russian Prince Who Became an England Rugby Legend

Prince Alexander Obolensky was not yet a British citizen when he was selected to play against New Zealand in January 1936. The choice of this son of an officer in Tsar Nicholas's Imperial Horse Guard, sent to Britain as a toddler to escape the revolution, was highly controversial. During the pre-match introductions the Prince of Wales, later Edward VIII, asked him pointedly: 'By what right do you play for England?' Obolensky replied 'I attend Oxford University ... Sir'.

In fact Obolensky had begun the process of obtaining British citizenship, and his selection was dependent on his assurance he would complete it. Any concerns about his status were entirely forgotten by the end of the game, in which Obolensky performed remarkably. England had never defeated New Zealand, and were not expected to do so that day, but, thanks to two spectacular tries from Obolensky, they did. *The Rugby Magazine* reported that it is for his second try that Obolensky is best remembered:

> Taking the ball on his own right wing he cut across the field to touch down just inside the left corner flag, outpacing the entire New Zealand defensive cover in the process. This was a highly unorthodox movement for the time and caught New Zealand unawares. For whatever reason they could find no way to counter England and the thirteen to nil final score line brought with it England 's first victory against the All Blacks. It would also be their last until 1973.

Twickenham today, 'a testament to William Cail's grand gesture'.

Prince Alexander Obolensky, the Russian who
became an English rugby legend.

Seventy years on, Frank Keating put it more poetically when he wrote in *The Guardian*:

> Just before half-time came the score to smithereen the bounds of orthodoxy with which
> the British game had saddled itself – and happily there was a British Movietone news
> camera in the West stand to record in flickeringly fuzzy sepia Obolensky audaciously
> stepping in off his wing to change left into right in a stride, and outrageously wrong-foot
> the cover which, to a man, screechingly had to pull up like infuriated cartoon cats. The
> dashing boy was off and away, untouched, to the left corner and immortality.

How the Burning of a Swastika into the Twickenham Pitch Was Kept Secret

The 1969–70 tour of South Africa in the UK was highly controversial. Opposition to
that country's racist regime was intense, and anti-apartheid protestors sought to disrupt
games, with efforts at the Twickenham match most determined.

Yet what would have been one of the most spectacular headline-grabbing stunts
was scuppered so effectively that it was not until forty years later that Peter Hain, the
organiser of the protests who later became a Labour cabinet minister, learned of it.

The burning of a Nazi swastika and the letters AA (for anti-apartheid) into the centre
spot were discovered by Harold Clark, clerk of works at the ground, early on the morning
of the game. As Chris Jones recounts in *The Secret Life of Twickenham*, Clark 'understood
how much coverage the damage to the pitch would give the protesters and took it upon
himself to gather up as many grass cuttings as he could and spread them over the
damaged area'. He may also have used green dye. 'He did such a good job that nobody
noticed the swastika or the letters during the game and he was able to fully restore the
grass after attention had moved away from Twickenham.'

Peter Hain had no knowledge of the
swastika incident, despite organising the
anti-apartheid protests.

The art of rugby. (Maxwell Hamilton under Creative Commons)

Peter Hain, when told of the action, said it 'must have been done by someone acting freelance. It is a good idea, but not something I knew about'.

How 'Swing Low, Sweet Chariot' Came to Be Sung at England Rugby Games

It was the final match of the 1988 Five Nations Championship – England versus Ireland. On the pitch was Chris Oti, England's first black player for eighty years. Oti scored a hat-trick in the 35-3 home win, a match that is regarded as a watershed in England's fortunes. When Oti scored his first try, a group of boys from Douai, the Benedictine school in Berkshire, followed a tradition at their school games whenever a try was scored and sang the hymn 'Swing Low, Sweet Chariot'. When Oti scored his second, the crowd around them picked up on the song and joined in. When he scored his third, the whole of Twickenham stadium was singing along. A tradition was born, and 'Swing Low' is now sung at all England home games.

However, this choice of song is not without controversy. The 150-year-old hymn is an American spiritual, sung originally by slaves, and can be interpreted as speaking of a desire for death to release them from an unbearable life. Singing it to celebrate a black player's achievements was interpreted by some as racist. That was certainly not the intention of the boys from Douai.

Others have claimed that the song has been sung in rugby clubs since the sixties to accompany drinking games. Whatever the truth, the song has been adopted by the fans as a celebration. A jazzed-up version called 'Swing Low (Run With The Ball)', was recorded

by the England players for the 1991 World Cup, and the reggae band UB40 recorded another version for the 2003 World Cup.

DID YOU KNOW?
In his teenage years Brian May, who would later form Queen with Freddie Mercury, was in a band called 1984, which rehearsed in Chase Bridge Primary School, Whitton. Their debut performance was at St Mary's Church Hall, Twickenham, on 28 October 1964, for which they were paid £10.

7. Twickenham and Teddington Film Studios

Both Twickenham and Teddington have played a significant part in the history of British film, television and music through the studios established in unlikely suburban settings in each. Both had quirky antecedents but went on to host some of the biggest stars: The Beatles at Twickenham and Morecambe and Wise, Benny Hill and Mr Bean at Teddington.

Twickenham Studios

Twickenham got its film studios as a result of a military doctor's disgust at the state of British cinemas. While Dr Ralph Tennyson Jupp was recuperating from injuries sustained during the Boer War, he was horrified at the poor hygiene and lack of ventilation at the

Twickenham Studios.

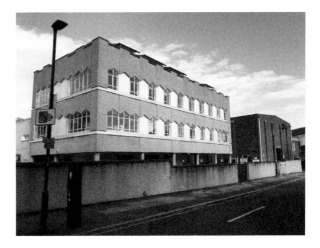

The studios are tucked away in The Barons, in suburban St Margaret's.

small seaside-town cinema he attended, and vowed that every large British town should have a really first-class movie house.

In 1909 he established the Provincial Cinematograph Theatres Company and began building a series of picture palaces. Four years later, concerned that so many of the movies available for screening were American, he decided to start making films to show in his growing chain of cinemas. Jupp founded London Films, converting a former ice rink in The Barons, St Margaret's, into an eight-studio complex, the largest facility in the UK at the time.

Jupp is described by Charles Allen Oakley in *Where we Came In: Seventy Years of the British Film Industry* as 'the one really outstanding man to participate in film making in this country in the years before the First World War.' Jupp was the first in the UK to combine the functions of producer, distributor and exhibitor. However, understanding that the Americans were so far ahead in this new art form, he hired his directors, technicians and leading actors from the States.

London Films' first production, *The House of Temperley*, was a big hit. At a time when most British studios were turning out ten- and twenty-minute short features, Jupp made only full-length films and sought to foster British talent and reduce his reliance on Americans. In 1917 his *Masks and Faces*, made to raise funds for the Royal Academy of Dramatic Art (RADA), featured cameo appearances from the playwright George Bernard Shaw and *Peter Pan* creator J. M. Barrie.

Sadly, however, Jupp had overreached himself. The enterprise that might have become a British rival to the emerging might of Paramount, Fox, Metro and Goldwyn began to falter. A combination of disappointing releases, the outbreak of the First World War, and Jupp's recurring illness meant that by 1916 he was virtually out of business. The studios were leased to other production companies, and in 1920 Jupp sold up.

In 1927, British film-making was given a shot in the arm by the Cinematographic Films Act, which decreed that 20 per cent of movies shown in British cinemas must be domestic productions. Julius Hagen took over and renamed the enterprise Twickenham Film Studios, the name it still bears today.

Studio successes include *The Private Life of Henry VIII* and *Saturday Night and Sunday Morning*.

Hagen began by turning out what were known as quota quickies, as fast as he could, but the success of his production of *The Private Life of Henry VIII*, directed by Alexander Korda in 1933, encouraged him to make more high-quality pictures. He made *Scrooge* in 1935 and *Spy of Napoleon* the following year. While the films were good, Hagen made a big mistake that led in 1937 to bankruptcy: he broke with his established distributors and attempted to distribute his films himself. The major studios blocked him from the American market, and he also failed to get into British cinemas.

The studio struggled on under new ownership through the Second World War when it suffered bomb damage. It was not until the 1960s that a turning point was reached with the arrival of Guido Coen as executive director. As Derek Pykett writes in *British Horror Film Locations*, 'Coen developed the studio's international profile, beginning with the hard-hitting drama *Saturday Night and Sunday Morning*, starring Albert Finney and Rachel Roberts. Under his guidance, Twickenham Film Studios would reach its peak.'

The Beatles at Twickenham

Many acclaimed sixties films were made here, including *Zulu*, *Alfie* and *The Italian Job*, but the films with the highest profile were *A Hard Day's Night* and *Help!*, starring the Beatles and directed by Richard Lester. Between 1964 and 1969 many of the band's film and TV appearances were filmed here, with location scenes shot in Twickenham.

When John, Paul, George and Ringo arrived to film *A Hard Day's Night* in March 1964, at the height of Beatlemania, fans stormed the place, breaking through the gates and

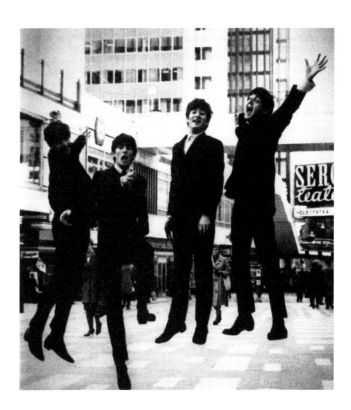

The Beatles in 1963. (Ingen Uppgift under Creative Commons)

The Beatles' first film, *A Hard Day's Night,* was made at Twickenham.

The Turk's Head pub, where Ringo filmed. (Jim Linwood under Creative Commons)

The Beatles returned to Twickenham to make their second film, *Help!*.

The four adjoining houses in Ailsa Road which the Beatles enter in *Help!*.

hiding out in studios and workshops. On 10 March, Ringo filmed comic scenes at The Turk's Head pub on Winchester Road, in which he buys a stale sandwich, breaks a glass, drops his change over a shove ha'penny board, and nearly skewers the pub parrot with a dart before being thrown out.

Location scenes for *Help!* included the four band members arriving in Ailsa Avenue in a black Rolls-Royce, separating and going through the front doors of four adjacent terraced houses: Nos 5, 7, 9 and 11. The camera cuts to inside, where we discover the doors all lead into one enormous living room, in which a gardener is cutting the turf carpet with a pair of false teeth.

When the band ceased live performances, they recorded promotional films at the studios, including one for *Hey Jude* in 1968. They also used Twickenham in January 1969 while rehearsing for a planned live performance to coincide with the release of their 1970 album *Let It Be*. The performance never materialised, but the sessions were filmed for a documentary by Michael Lindsay-Hogg.

Relations between band members had deteriorated badly by this time, with particular tensions between George Harrison and Paul McCartney. Harrison walked out at one point, and later referred to 'the winter of discontent at Twickenham'. John Lennon called the time here 'hell ... the most miserable sessions on earth'. The Beatles split up on 10 April 1970.

Modern Threat

Twickenham has continued to produce first-class films over subsequent decades, including *Straw Dogs, Superman II, Gandhi, Blade Runner, A Fish Called Wanda, Calendar Girls, The Best Exotic Marigold Hotel, Warhorse*, and *Bohemian Rhapsody*. TV shows have included *Poirot, Black Mirror, The Durrells, McMafia,* and *Inside No. 9*.

However, in 2012 the story almost met a premature end after the studios went into receivership and builders Taylor Wimpey put in an application to put housing on the site. Twickenham Studios was saved by Maria Walker, who lived in St Margaret's and had a twenty-five-year career in film production. She started a petition that circulated to everyone in the industry she could think of – including movie director Steven Speilberg – and gathered 7,000 signatures.

The developers withdrew their application and sold the site to Sunny Vohra, a movie buff with no experience in the industry. He hired Maria as chief operating officer, the studios were overhauled and brought up to date, creating a first-rate modern facility with fifty permanent staff, and the work came flooding in.

DID YOU KNOW?
Neil Aspinall, often referred to as the fifth Beatle, and who ran the group's business empire for forty years, lived in Twickenham. Mourners at his funeral in St Mary's included Yoko Ono and Stella McCartney. During the service, The Who's Pete Townshend performed 'Mr Tambourine Man' by Bob Dylan and 'My Sweet Lord' by the late Beatle George Harrison.

Teddington Studios

A century of film-making at Teddington Studios began with a rainstorm and a wealthy stockbroker and student of the infant art of cinematography called Henry Chinnery. When a downpour forced a group of local film enthusiasts to call 'cut', he took pity on them and invited them to set up their camera in the large greenhouse of his substantial Thames-side residence, Weir House in Broom Road. Chinnery was immediately bitten by the film-making bug.

In 1912, a company of nine actors who were appearing at the Kingston Empire and Richmond Hippodrome, now Richmond Theatre, raised £1,000 and established a film company called Ec-Ko. Their office was in Teddington, at No. 176 High Street, and Chinnery allowed them to film their ten-minute silent comedies in the grounds, greenhouse and stables at his forty-room home.

Ec-Ko lasted six years before being succeeded by Master Films, which continued to use Weir House to film full-length features here, buying the house in 1920. Once it owned the property, the company set about constructing a purpose-built studio: a steel structure clad in glass to maximise available light, and the coach house and stables were converted into dressing rooms, workshops and a small preview theatre. The last film the company made, in 1928, was *His House in Order*, starring Tallulah Bankhead.

In 1931 the studios were sold to the film-maker E. G. Norman and silent-screen actor Henry Edwards. They decided talking pictures were the future and built new, soundproof studios with a sound-recording system, giving their enterprise the name that would live on until 2014: Teddington Studios. They made just one film before leasing the studios to the powerful American company Warner Studios.

Warner began by turning out quota quickies at Teddington, some completed in less than a week. Weir House was used as accommodation for Warner executives and stars, but the Americans found resources extremely limited compared to those at Warner's Burbank Studios in California. One morning, at 6 a.m., managing director Irving Asher was woken by prop Master Harry Hanney, and asked to get up because his bed was needed for a scene that was about to be shot.

Teddington Studios.
(Redvers under
Creative Commons)

The redeveloped studio site today.

Benny Hill, among Teddington's biggest stars. (Ricardo Liberato under Creative Commons)

The first film Warners made here was *Murder on the Second Floor,* which included location scenes shot in Teddington High Street. They went on to feature stars including Rex Harrison and Margaret Lockwood. A young Errol Flynn, appearing in his first starring role, in *Murder in Monte Carlo*, so impressed them that he was whisked off to Hollywood, where he enjoyed a stellar career.

In 1934 Warner bought the studios and rebuilt them with a grand façade. Over thirteen years, Warner made 150 films at Teddington, including the first of Max Miller's eight comedies, *Get Off My Foot.*

Benny Hill lived, and died, at 7 Fairmile House, No. 34 Twickenham Road.

Teddington was one of the few film studios to continue production during the Second World War but, in October 1944, a doodlebug – a V1 flying rocket – struck the powerhouse and the studios were wrecked. Many buildings had to be completely rebuilt, and production did not restart until 1948, when the restored studios were reopened by Danny Kaye. However, Warner Brothers pulled out in 1952, and for six years the site was leased to the Hawker Aircraft Company.

DID YOU KNOW?
Noel Coward was born at No. 131 Waldegrave Road, Teddington, in 1899 and lived here until 1908. His musical family were mainstays of St Alban's Church in Manor Road. He wrote in his autobiography: 'the church's greatest asset was the Coward family, which was enormous, active, and fiercely musical. My Uncle Jim played the organ, while my father, together with my uncle Randolph, Walter, Percy, and Gordon, and my Aunt Hilda, Myrrha, Ida, and Nellie, graced the choir. Aunt Hilda, indeed, achieved such distinction as a *coloratura* that she ultimately became known as "The Twickenham Nightingale".' Coward was among the stars of the 1960s classic movie *The Italian Job*, filmed at Twickenham Studios.

Noel Coward's former home at No. 131 Waldegrave Road, Teddington, bears a blue plaque. (Allan Warren and Spudgun67 under Creative Commons)

Teddington Studios' TV successes included
The Avengers, starring Diana Rigg, and
Rowan Atkinson's *Mr Bean.* (Antonio
Zugaldia under Creative Commons)

Saved by Television

Television saved Teddington Studios when, in 1958, the ITV franchisee ABC bought the site and filmed shows including *Armchair Theatre.* In 1960 it made what would become its most successful series, *The Avengers,* here. Over twenty years the company, which became Thames Television, filmed hit shows including *Minder, Callan* and *The Benny Hill Show.*

Benny Hill was one of the most popular television comedians and his show was among the most-watched programmes of all time, peaking at over 21 million in 1971 and being screened in ninety-seven countries. Hill, however, was a solitary, troubled figure who never owned his own home, but rented a flat a few minutes' walk from the studios, at 7 Fairmile House, No. 34 Twickenham Road. He died alone here in 1992, his body only discovered two days later.

Teddington continued to produce a wide range of television programmes, including *Morecambe and Wise, Reggie Perrin, My Family, Not Going Out* and *Mr Bean,* until 2014, when then owners, Haymarket, sold the site for housing and the studios were demolished.

8. Weapons of War

A Medieval Weapons Factory on the River Crane

In Crane Park, on the banks of the River Crane between Twickenham and Whitton, a round stone tower stands sentinel. This is the last remaining evidence of what was once among the largest gunpowder works in Europe, established during the reign of Henry VIII, if not before, and where production continued until 1927.

It was an ideal spot for a very dangerous business: this area of Hounslow Heath was remote and sparsely populated; one of gunpowder's constituents – charcoal – could be made from the willow and alder that grew along the banks of the Crane; the fast-flowing river powered the mills; and barges could then take the explosive downstream to the Thames for London.

The charcoal would be ground to a powder and mixed with the other constituents – sulphur and saltpetre (potassium nitrate). Previously, gunpowder was imported, but

The shot tower at the former gunpowder works in Crane Park. (Maxwell Hamilton under Creative Commons)

Gunpowder Mill ruins in Crane Park. (Andy Scot under Creative Commons)

during Henry's reign it became apparent that England must manufacture its own if it was to be certain of reliable supplies to wage war.

The tower, which was restored in 2004, was actually part of another weapon-making process. It was a shot tower where, from 1823, globules of molten lead were dropped from a height into a tank of cold water. The lead formed spheres as it fell, which hardened when they hit the water, creating primitive bullets which, with the addition of a gunpower charge, could be fired from a musket. In another of the mills there was a sword foundry.

By the mid-eighteenth century, several gunpowder mills were in operation on the Crane between Baber Bridge and what is now Crane Park. With large quantities of wood being burned to make charcoal close to where gunpower was stored, explosions were frequent.

In 1758, a blast caused an earth tremor that was felt 19 miles away in Maidenhead. In 1772 three mills exploded, in a blast that could be felt 45 miles away in Selbourne, Dorset. Horace Walpole complained to the Lieutenant General of the Ordnance that the explosion had blown all the stained glass out of his house at Strawberry Hill. In the most severe accident, in January 1796, a barge loaded with thirty barrels of powder caught fire, the flames spreading to the mill. In the resulting explosion, houses were damaged in Hounslow, Isleworth and Brentford.

One local diarist, Joseph Farington, noted: 'The powder mills at Hounslow were blown yesterday. The concussion was so great as to break the windows in the town of Hounslow ... [at] the spot where the mills had stood, not a fragment of them remained. They were scattered over the country in small pieces. Three men were killed.' In fact, there were four fatalities recorded in the deaths register at St Mary's Twickenham. Parish records note a succession of deaths through to 1915.

DID YOU KNOW?
Teddington Studios owned a series of boats that were moored at its site alongside Teddington Lock and were used for entertaining stars. They included the motor vessel *Iris*, which, in 1940, was one of the Little Ships that rescued British troops from the beaches at Dunkirk.

Teddington and the Little Ships

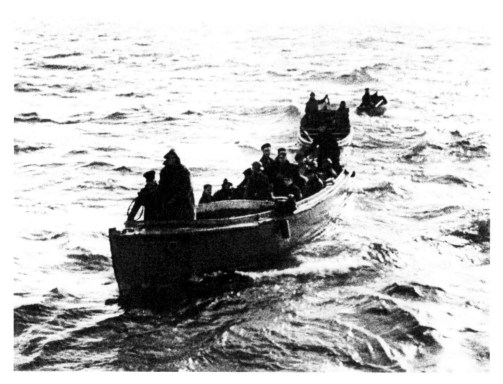

Douglas Tough mobilised around 100 Little Ships from the Thames.

The former Tough's boatyard today.

In May 1940, Douglas Tough mobilised around 100 Little Ships, which played a key part in Operation Dynamo, the secret mission to rescue 385,000 soldiers from the beaches at Dunkirk. Douglas ran Tough's Boatyard at Teddington, and this was just the most dramatic element in a sustained effort to help win the war. Only sixteen men worked at the yard at the outbreak of hostilities, but by 1945 that number had risen to 220. The yard-built vessels for the fire service, which were used in the London docks during the Blitz, and Tough's workers would travel the length of the south coast repairing fishing and other boats damaged by enemy action.

Douglas Tough towed a fleet of small Thames pleasure boats from Teddington to Sheerness, the craft crewed by 200 amateur sailors he had recruited, where they were fuelled and motored on to Ramsgate, to be handed over to the navy for the crossing. The boats' owners had not been told the purpose of their mission, although they had a good idea, and many demanded to be allowed to sail their own ships across the channel. Douglas's son Bob, who was thirteen at the time, later recalled: 'People half-guessed what was happening, because we knew about Dunkirk and we understood that the Army would have to be evacuated somehow. There was this sense of doing whatever had to be done.'

On the sixtieth anniversary of the rescue in 2000, Bob joined hundreds of veterans who sailed back to Dunkirk on the same small boats.

How Eisenhower Planned D-Day from Bushy Park

For three months in 1944, General Dwight Eisenhower planned the Normandy landings from his headquarters at Camp Griffiss, a 60-acre site at the park. The general's presence here was a closely guarded secret for fear that, should the location become known to the Germans, an assassination attempt would be launched.

Eisenhower, who would become US president from 1953 to 1961, moved his Supreme Headquarters Allied Expeditionary Force (SHAEF) from Grosvenor Square to the park, where he planned Operation Overlord, which saw 150,000 Allied troops storm the Normandy beaches on 6 June 1944 in the D-Day landings.

By some accounts, Eisenhower moved to a house on the edge of the park, Bushy Park Cottage, No. 129 Park Road, Teddington, for the three months it took to prepare for the invasion. The cottage is actually a substantial house built as a hunting lodge for George III in 1762. By other accounts he remained at Telegraph Cottage, close to Richmond Park, where he had lived from 1942. The Teddington Society record:

> It was intended that he should stay at quarters in Whitehall, where he could be protected and could use its bunkers should it be necessary. However, he said he would prefer to be close to his troops and moved in to Bushy Park Cottage in early 1944 where he remained until the troops moved to Portsmouth for the D-Day landings. Eisenhower stayed in the house with his chauffeur, Kay Summersby, who was a member of the British Mechanised Transport Corps and later became his secretary and, it is alleged, his mistress.

The camp was named after Lieutenant-Colonel Townsend Griffiss, the first US airman to die in the line of duty in Europe when, in an incident of friendly fire, he was shot down by

General Eisenhower planned D-Day from his Bushy Park HQ.

The USAAF memorial in Bushy Park. (Jonathan Cardy under Creative Commons)

Eisenhower's former home, Bushy Park Cottage.

a Polish pilot in the RAF. The camp's many huts had been removed by the early 1960s, and two memorials close to Chestnut Avenue now mark the site. One, dedicated to the Allied troops killed on D-Day, marks the spot where General Eisenhower's office stood.

Bushy Park also played a key role post-war when, in 1948, the United States Air Force were stationed here while they coordinated the Berlin Airlift, the Allies' successful campaign to overcome the blockade of air, sea and road links to East Germany, which was designed to force the western powers to abandon their protectorates in the city.

Bushy Park, the Spitfire, Bouncing Bomb and Alan Turing

The role of the National Physical Laboratory sounds remarkably dry. Established at Bushy House in 1900, its task was to conduct research into the accurate determination of

physical constants, to establish and maintain precise standards of measurement, and to make tests of instruments and materials.

Yet, research done here was of vital importance in winning the Second World War. The first experiments in radar were conducted on the sports field, and the wind tunnel was used to perfect the design for the Spitfire, the fighter that achieved dominance at the Battle of Britain. Barnes Wallis first tested his Bouncing Bomb, which breached the Mohne and Eder dams in 1943, severely impacting the German war effort, in tanks here. Also designed here were Mulberry harbours, floating concrete platoons that were towed across to the Normandy beaches and joined to form substantial harbours that were vital for supplying the troops; plus PLUTO, the pipeline through which fuel was pumped across the Channel.

In 1945 Alan Turing, the key figure in wartime code breaking at the Government Code and Cipher School, Bletchley Park, and one of the founding fathers of modern computer science, came to work at the National Physical Laboratory. For two years he worked on building one of the first computers.

During this time Turing lived at Ivy House in Hampton High Street, where a blue plaque records his stay. He was a keen marathon runner and, as well as jogging to work through Bushy Park, he would also run the 18 miles to his mother's house in Guildford for Sunday lunch.

The NPL is still based at Bushy House and is administered by the Department for Business, Energy and Industrial Strategy. Its current work includes research into nanotechnology, which enables scientists and engineers to see and control individual atoms and molecules and to tailor the structures of materials to achieve specific properties, making them – for example – stronger, lighter, more durable, or better conductors of electricity. Nanotechnology has made possible lightweight body armour; applying clear film to glass to make it non-reflective, self-cleaning and electrically conductive, and creating lightweight polymer composites that can be used in the manufacture of a huge range of everyday items from cars to tennis racquets.

DID YOU KNOW?

One class of boat was not up to the journey across the channel to Dunkirk. These were the Thames pleasure steamers, which were designed to take on fresh water to feed their boilers. When it was discovered that salt water was making them inoperable, Admirable Taylor wired from Sheerness: 'Thames river steamers have no condensers and cannot run on seawater. Request no more be sent.' Vessels owned by Mears, of Eel Pie Island, including *His Majesty, Royal Thames, Viscountess, Connaught, Kingwood, The King, Abercorn, Hurlingham* and *Marchioness*, were left at Sheerness when the fleet sailed on, to be towed back upriver later. There they resumed their wartime role as floating hospitals.

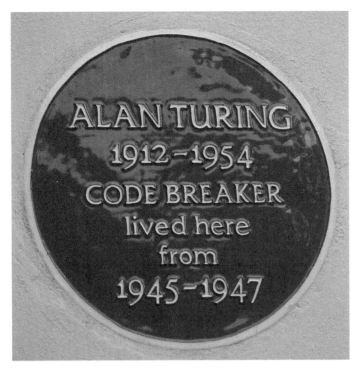

ALAN TURING
1912–1954
CODE BREAKER
lived here
from
1945–1947

Alan Turing's former home in Hampton High Street is marked with a blue plaque. (Edwardx under Creative Commons)

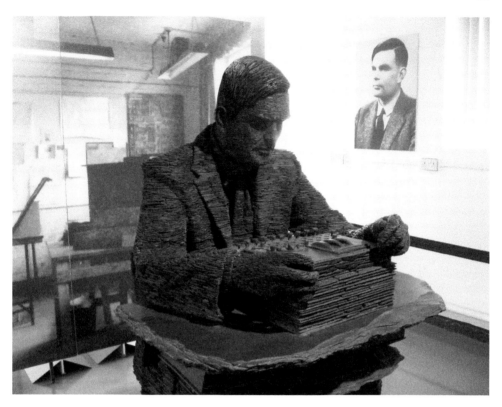

A sculpture honouring Alan Turing. (Jon Callas under Creative Commons)

Bibliography

In writing this book, I have read or consulted the following books, publications and websites:

Anon, *Benny Hill in Teddington* https://flashbak.com/the-rise-fall-and-lonely-death-of-benny-hill-371668/

Anon, *Eel Pie* www.eelpie.org

Anon, *Fish and Fishing on the Crane and Duke's River* https://www.force.org.uk/assets/documents/wr-201410-crane-fish-and-fishi

Anon, *Reminders of the part played by Bushy Park in World War Two* http://www.fbhp.org.uk/images/downloads/ww2-memorials-douglas.pdf

Anon, *Studio Stays in the spotlight Richmond and Twickenham Times* https://www.richmondandtwickenhamtimes.co.uk/news/884832.studio-stays-in-the-spotlight/

Anon, *The Dunkirk Project* https://thedunkirkproject.wordpress.com/the-dunkirk-project-2/the-dunkirk-project/27th-may-1940-an-extraordinary-armada/

Anon, *Teddington Studios* http://www.twickenham-museum.org.uk/detail.php?aid=215&cid=3&ctid=2

Baker, Rob, *Beautiful Idiots and Brilliant Lunatics: A Sideways Look at Twentieth-Century London* (Stroud: Amberley, 2015)

Barnfield, Paul, *Hampton Wick Part 1: Up to 1800* (Twickenham: Twickenham Local History Society, 2004)

Campbell, Gordon, *Garden History: A Very Short Introduction* http://www.londongardensonline.org.uk/gardens-online-record.php?ID=RIC073

Coward, Noël, *Present Indicative: The Autobiography of Noël Coward, Vol. 1* (London: Heinemann, 1937)

Francis J. M., Urwin A.C.B., *Francis Francis 1822-1886 Angling and Fish Culture in Twickenham, Teddington and Hampton* (Twickenham: Twickenham Local History Society Paper 65, 1991)

Harris, Edmund, *Twickenham Rugby Ground 1906-1910: A Grand Gesture* (Kingston: Kingston University, 2002)

Jessop, Miranda, *The Woman Keeping Showbiz in Twickenham* https://www.essentialsurrey.co.uk/theatre-arts/maria-walker-saves-twickenham-studios/

Jones, Chris, *The Secret Life of Twickenham* (London: Aurum Press, 2014)

Keating, Frank, *Seventy Years on, England's Prince Obolensky is Still Remembered* https://www.theguardian.com/sport/blog/2010/mar/24/prince-alexander-obolensky-england-russian

Lee, J. M., *The Making of Modern Twickenham* (London: Historical Publications, 2005)

Marzials, Theo, *Hammerton Ferry Song* (Unknown, 1878)

Mears, Joseph, *The Thames London to Windsor* (London: Cohen, 1925)

Oakley, Charles Allen, *Where We Came In: Seventy Years of the British Film Industry* (London: Routledge, 2016)

Page, Jimmy, *Liner Notes for Blues Anytime Vol 3* (London: Immediate, 1968)

Pearce, Brian Louis, *The Fashioned Reed: The Poets of Twickenham from St Margaret's to Hampton Court from 1500* (Twickenham: Twickenham Local History Society, 1992)

Pearce, Garth, *Rod Stewart: I saw Jagger perform and thought 'I could do that'* https://www.express.co.uk/entertainment/music/609669/Rod-Stewart-Eel-Pie-island-50-years/amp

Poupart family website http://www.poupart.com/NewFiles/poupartltd.pdf

Pykett, Derek, *British Horror Film Locations* (London: McFarland, 2008)

Richmond Council Local History Resource *Bushy House and the National Physical Laboratory, Teddington* https://www.richmond.gov.uk/media/6329/local_history_bushy_house.pdf

Rose, David *The Poupart Family in the Borough of Twickenham* (Twickenham Local History Society, 2002)

Rugby History Society http://therugbyhistorysociety.co.uk/obolensky.html

Rugby Magazine, *The Obolensky's Match* https://therugbymagazine.com/legend-series/alexander-obolensky-englands-flying-prince

Simpson, D. H., Morris, E. A., *Twickenham Ferries in History and Song* (Twickenham: Borough of Twickenham Local History Society Paper No. 43, 1980)

Souden, David, and Worsley, Lucy, *The Story of Hampton Court Palace* (London: Merrell, 2015)

Teddington Society, http://www.teddsoc-wiki.org.uk/wiki/index.php?title=Park_Road_129,_%22Bushy_Park_Cottage%22

Telegraph, Daily, *Bob Tough obituary* https://www.telegraph.co.uk/news/obituaries/9306429/Bob-Tough.html

Van der Vat, Dan and Whitby, Michelle, *Eel Pie Island* (London: Frances Lincoln, 2009)

Vickers, Miranda, *Eyots and Aits: Islands of the River Thames* (Cheltenham: History Press, 2012)

Wheatley, J. C., Whitby, Michelle, *The British Beat Explosion: Rock 'N' Roll Island* (London: Aurora Metro, 2014)

Wilkins, Leslie T., *Unofficial Aspects of a Life in Policy Research* (New York: State University of New York, 2000)

Willson, Anthony Beckles, *Alexander Pope's Twickenham 1719–1744* (Twickenham: Pope's Grotto Preservation Trust, 2007)

Willson, Anthony Beckles, *Alexander Pope's Grotto in Twickenham* (Twickenham: Twickenham Museum, 2014)

Webber, Ronald, *Covent Garden: Mud Salad Market* (London: Dent, 1969)

Wood, David, *The Making of Twickenham's Embankment* (Twickenham: Twickenham Museum Occasional Paper No 5, 2012)

Young, Arthur M, *The Ferry to Fairyland* (Unknown, 1915)

Acknowledgements

The author and publishers would like to thank the following people/organisations for permission to use copyright material in this book: The Wellcome Collection for images from its archive, and the many photographers who have made their work available under Creative Commons.

I would also like to thank: Richmond Council Local History Resource; Pope's Grotto Preservation Trust; Eel Pie Island Museum; the Twickenham Local History Society, for publishing so many fascinating papers on the area; and to acknowledge the enormously valuable online resource of the Twickenham Museum at http://www.twickenham-museum.org.uk/.

Every attempt has been made to seek permission for copyright material used in this book. However, if we have inadvertently used copyright material without permission/acknowledgement we apologise and will make the necessary correction at the first opportunity.